THE CONTEMPORARY QUILT

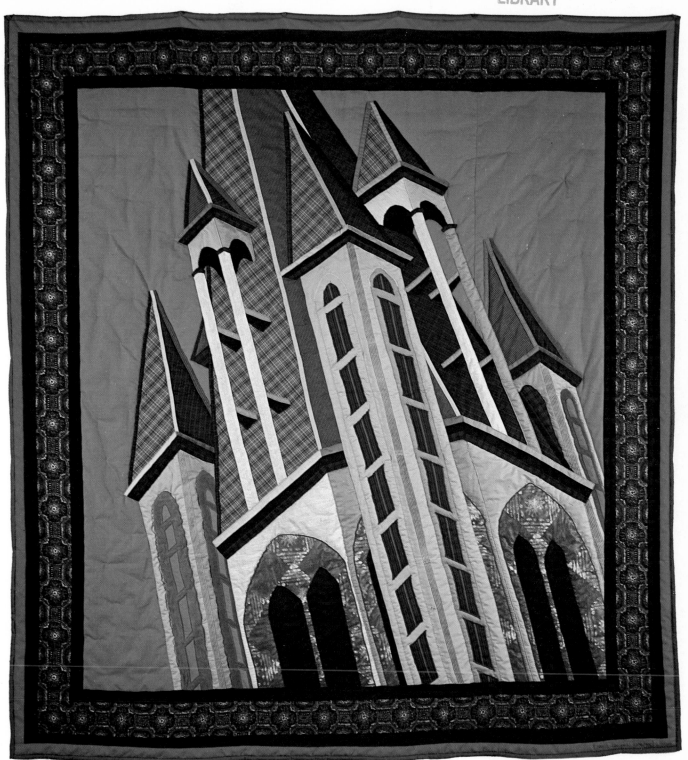

1 (above). *Spires, Coutances Cathedral,* Susan Hoffman, 1975. 76″ x 72″. Cotton. Pieced, appliquéd, quilted, and tufted. The artist's intention, in making this quilt, was to take the viewer beyond its existence as a quilt into the visual experience. Photograph: Eeva-Inkeri. (Sydney and Frances Lewis)

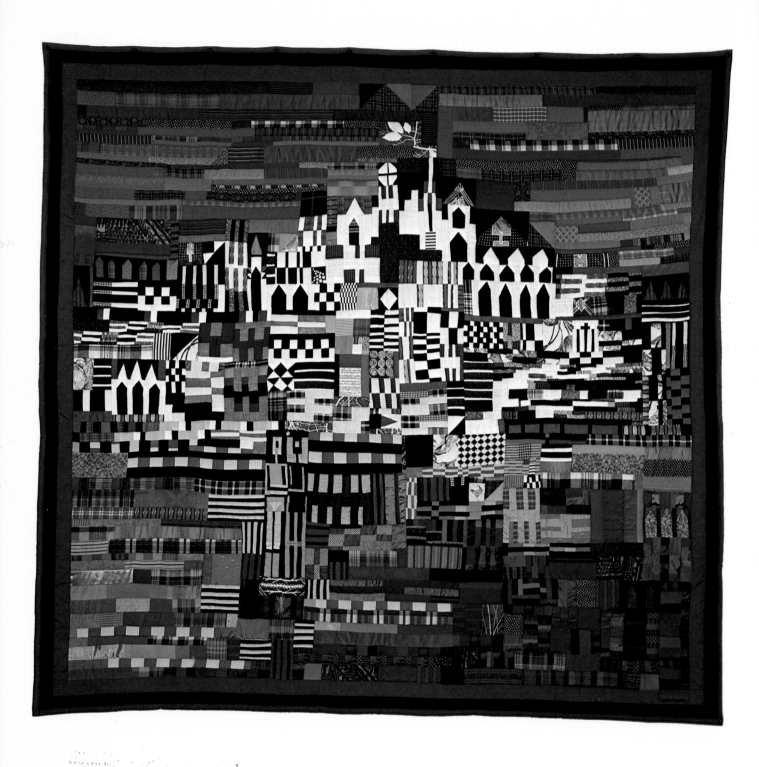

2 (above). *Torrid Dwelling*, Molly Upton, 1975. 92″ x 98″. Cotton, cotton blends, and wool. Pieced and quilted. The inspiration for this quilt came from wanderings through ruins, active streets, and deserts; from past civilizations and keyboards. Photograph: Russell Windman. (Penny Dunning)

THE CONTEMPORARY QUILT

New American Quilts and Fabric Art

by

Pattie Chase

with

Mimi Dolbier

Foreword by Radka Donnell

A Dutton Paperback

E.P. Dutton
New York

Book Designed by George H. Buehler

First published, 1978, in the United States by E. P. Dutton & Co., Inc., New York. /
All rights reserved under International and Pan-American Copyright Conventions. /
No part of this book may be reproduced or transmitted in any form or by any means,
electronic or mechanical, including photocopy, recording, or any storage and retrieval
system now known or to be invented, without permission in writing from the publishers,
except by a reviewer who wishes to quote brief passages in connection with a review
written for inclusion in a magazine, newspaper, or broadcast. / For information
contact: E. P. Dutton, 2 Park Avenue, New York, N.Y. 10016. / Published simultane-
ously in Canada by Clarke, Irwin & Company Limited, Toronto and Vancouver. /
Printed and bound by Dai Nippon Printing Co., Ltd., Tokyo, Japan. Library of Con-
gress Catalog Card Number: 78-59313. / ISBN 0-525-47523-0 (DP); ISBN
0-525-17441-9 (Cloth). *First Edition.*

CONTENTS

PREFACE

In recent years there has been a strong revival of interest in quilts. Numerous new books have appeared on the subject, and, with few exceptions, they have dealt with traditional designs and techniques. The focus, thus, has been entirely on conventional quiltmaking.

Without denying the relevance or the importance of tradition, we think it is time that quiltmaking and other fabric arts be viewed in a new light. *The Contemporary Quilt* presents the work of some sixty women who are producing spectacular contemporary fabric art that beautifully expands our understanding of quilts. In assembling this book, we chose quilts and fabric art that we believe best represent the many and varied elements of creative concept and technique that have brought quiltmaking out of the realm of functional domestic crafts to stand alongside the more universally recognized art forms such as painting, sculpture, and graphics as a valid means of artistic expression.

A wide spectrum of background and experience is represented here. Some of the contributing artists have received national recognition for their work through exhibitions, galleries, and reproductions in books and other publications. For others, this is the first exposure for their work. The artistic backgrounds, the life-styles, and the viewpoints of these women are as varied as their techniques.

While collecting work for this book, we invited the artists to comment on a number of subjects that seemed relevant. We were interested not only in what they had created, but also in why and how they had chosen to work in fabric.

Space prohibits the inclusion of complete texts of the artists' comments, which ranged from casual remarks to formal statements about their work, their specific techniques, and their intentions. Their insights, many of which are included, were extremely valuable in giving shape to the book. They defined certain affinities and common points of reference for working with fabric; they defined as issues problems inherent in fabric arts: function versus aesthetics, art versus craft, tradition versus innovation, artistic and cultural chauvinisms as they affect their work. These were by no means the only concerns pertaining to fabric arts, but simply the most general and the most universal.

Obviously, there is no single approach to working with cloth nor any one point of view on the issues just mentioned. Each artist has worked out her own best solution or, perhaps more accurately, is continually dealing with solutions through the processes of her work. The work, in that sense, speaks for itself.

MIMI DOLBIER

FOREWORD

The general upsurge in the making of patchwork quilts over the last ten years in this country marks a genuinely popular trend and is an art phenomenon that is only beginning to be understood. There have always been quilt lovers and quilt connoisseurs, but the artistic and human issues of this tradition have come into focus only recently.

There are many characteristics of patchwork quilts that generally recommend them. Being traditionally a women's art product, quilts assert the creative potential of everyone. The very manner of their composition demonstrates the American dream of creating "unity out of diversity." As much discipline as freedom can go into their making. Putting a quilt together is a physically and emotionally integrative process, and it is a "coming home" to all the strength, ingenuity, and love already realized by women as a tradition. Quilts admit design ideas from manifold constructive human activities indoors and out. From paving, building, roofing, paneling, and tilling the soil to weaving, embroidering, and the making of mosaics and stained-glass windows, there is no kind of constructionist and fill-in procedure that has not been welcomed as a creative principle in quiltmaking.

The resourcefulness of American women, who have defined quilts as an art form, lies as much in their invention of designs as in the daring with which they incorporated the assembly methods from other work processes. Working in cloth they developed systems of joining and combining formal elements in a way that expressed emotional values and connected diverse fields of human production. Consequently, the creation of an international approach to design that is truly pluralistic, comprehensive, and uninhibitive owes an untold debt to American women. Almost every ethnic ornamental tradition has been drawn upon in this process: American Indian, Afro-American, Anglo-Saxon, Asian, Hawaiian, East Indian, East European, Scandinavian, and Baltic, all coming together into a single language of generalized abstract or stylized forms charged with feeling. Taken together or individually, quilts have served as a great depository of compositional devices, and have thus largely supplied the visual matrix that modern American artists, male and female painters and sculptors, have consciously or unconsciously drawn upon.

But are the pioneering days of quilt design over? Are our expectations of what quilts ought to look like

completely set? Has a final hardening taken place, and have women gotten used to making quilts purely imitatively, in a rote, nostalgic or conventional way? Is there such a thing as a *new* American quilt? And what might such a thing be now? Necessarily, it's a structure consciously referring to the quilt tradition and making a strong personal statement on that basis.

In modern painting one can often recognize the modular block structure of quilts (Ad Reinhardt), their grid layout (Andy Warhol's flower and portrait modulars), their vocabulary of geometrical sections (Ellsworth Kelly, Josef Albers), their characteristic patterns (Alfred Jensen), and even entire quilts (Robert Rauschenberg). The compositional look of quilts has been appropriated by artists in other media, so much so that to approach the tradition creatively now surely means to first reassess the material nature of quilts—the mother structure that yielded so many riches—for what it may still hold for us.

The making and the using of quilts occupy the important junction of the intimate and the public spheres. The combining of materials that normally, as clothing, are close to the body or, as covers, are next to it expresses that instinctive daring in the presentation of one's self to the world and says something about our bodily identity. And this is responsible for the vigor of the designs and the devices of color that still make some old quilts stronger statements than many contemporary paintings.

This creating from the body outward and then oriented back again toward it, leads to personal, not "decorator's" or computerized color choices. The textiles used actually have strong tactile characteristics and form a field and an associative context for the body and the person, as identical with it. In the textiles, the material, the graphic, and the symbolic aspects coincide substantially in their evocation of the body. Because cloth is associated with body temperature, all the sensual qualities of cloth—be it color, texture, or overall design—imply the body: its joys, it sensibilities, and its vulnerability. Quilts thus are witness to the dependence of both the artist and the spectator on the man- and woman-made textile environment. Clothing, drapery, wraps, and covers of every kind constitute that soft continuum of human invention and care with which humankind imbeds itself in the extremes of nature and its own stark architectural creations. Quilts, as fabric arts, speak of warmth, closeness, contact, and union among persons —all experiences not allowed to predominate in our times. This material-and-feeling quality of quilts, as it runs up against many kinds of chauvinism at the same time—local, professional, male, and commercial—challenges a great many ideas and makes quilts into a liberation issue.

This same material-and-feeling quality that makes quilts special among art objects consists in their nature as covers that are themselves objects of various thicknesses, as well as envelopes for objects. In their function as covers, quilts explore and dramatize the interplay between flatness and three-dimensionality. They are, as it were, simultaneously the fish and the net. The relief quality of quilts and the surface articulation of the quilting soften the hardness of the seams and edges and tilt planes into one another. The multitude of angles from which, spread or hung, they can be viewed and touched, adds to their direct impact and their long-lasting, subtle effects. By its original closeness to a person's body the quilt can become an icon of personal feeling and hope. This is its nature, invoking no absolutes, but open as to a human embrace.

RADKA DONNELL

INTRODUCTION

American women have always made quilts. From the purely functional rag quilts of the first American settlers and the colorful geometric quilts that soon followed to the startling new-age quilts pictured in this book, quilts have been the most visible contribution of women to American art.

In all parts of the world women's arts and the cloth and fiber arts have generally been one and the same. For this reason the vibrant patchwork quilts of North American women have much in common with the bright weavings of South American women, the reverse appliqué of Central American Indian women, the dyed and printed cloths of African women, the decorative garments of Near Eastern and Far Eastern women, the exquisite embroidery and needlework of European and Asian women, the beadwork and weaving of Native American women, and the meticulous appliqué quilts of Polynesian women. These skillfully sewn and woven art works, both decorative and functional, have linked women historically and artistically for thousands of years. This is a strong common bond, and the piecework quilts with which we are so familiar are very much a part of this ancient affinity between women and cloth.

American women began to make quilts almost as soon as they set foot on these shores. Bringing their fine European needlework skills with them, the earliest settler women at first fashioned only the simplest quilts, for the New England winters were bitterly cold and the need for warm bed coverings was immediate. Cloth was a luxury then and not a scrap could be wasted, so they pieced together blankets and coverlets from the remnants of worn-out clothing. These first "catch-as-catch-can" quilts were probably rough and drab, but they served an important purpose and preceded the prismatic pieced quilts that have become so familiar and are so much a part of our American design heritage.

The early quiltmakers probably gave little thought to the first pieced coverlets they made; it was not until they were well established in this country that they began to make their quilts with more attractive kinds of fabric and to give some attention to design. Probably the first scrap quilts became more than just functional bedcovers when an early quiltmaker decided that a piece of red fabric was more attractive beside a piece of blue fabric than beside an orange piece. It was an aesthetic rather than a practical choice. It cannot have been long after that that imaginative women began to cut their precious scraps of cloth into specific shapes—squares, diamonds, triangles, octagons, hexagons, trapezoids, and the like—and to piece them together into increasingly intricate geometric designs. So careful and so clever were most women in using every bit of available fabric in their quilts that some early geometrical piecework designs involved pieces cut as small as an inch wide.

These early geometric designs were shared among women as quickly as they were invented and were given names such as Log Cabin, Lone Star, Birds in Flight,

Road to California, and so on, in accordance with the natural shapes, colors, and occurrences of everyday existence. Biblical and political themes were also quite common. Besides being wonderfully descriptive, the several names given to similar quilt designs, which varied from the rural areas to the cities and from one part of the country to another, told much about the lives and viewpoints of the women who made them. Some quilt designs were known by as many as ten different names from one part of the country to another.

By the mid-nineteenth century there were probably more than one thousand geometric and appliqué quilt designs and their variations familiar to American women. Because the traditional geometric designs allowed hundreds of variations, new designs were constantly being created. Pieced and appliquéd designs had become increasingly intricate, and both rural women, with their colorful and exuberant scrap quilts, and urban women, with their sophisticated abstract quilts, exhibited great design understanding. Among them they had developed a body of decorative American art that was strong and vital.

So, although it originated as a functional craft form, by the mid-1800s the pieced quilt had become an American design tradition that went far beyond utility. It is clear from the sophisticated design concepts that quiltmakers were generally more interested in the beauty than in the function of their quilts. This does not diminish the functional aspect of quiltmaking, but the great beauty, dramatic design elements, and strong visual and textural impact of the early quilts unquestionably made them art.

The transition of quilts from craft to art form can be attributed to the fact that quiltmaking has always been a women's art, and that women have always been comfortable and creative with fiber and cloth. Once quiltmaking became established as an art form, it was clear that domestic utility was not the primary concern of quiltmakers. Long after the Industrial Revolution had made quiltmaking functionally unnecessary, since machine-made blankets and spreads were readily available, women continued to make quilts in great numbers.

Quiltmaking, along with other needlework arts, was tremendously important to the American woman. It provided a means of artistic expression in a difficult environment, something soft and resilient in a hard life that left little room for female sensibilities; and it was one of the few American folk art traditions that women had developed and could control. Without access to other art forms (for certainly the skills and tools for painting, sculpture, and the other fine arts were not available to most of them), women in early America made their art with what was at hand: fabric and fiber. They created, out of bits of cloth and their own best visions, the spectacularly visual pieced and appliqué quilts that have become their artistic totems and our artistic heritage.

Contrary to the belief of some art historians, who

have suggested that quiltmakers were unaware of the sophisticated nature of their designs, women were surely aware of the great artistic value inherent in their quilts. It is impossible to believe that a woman would cut hundreds, sometimes thousands of pieces of fabric, laboriously piece them together into intricate chromatic and geometric designs, put several miles of stitches into the whole pieced surface to create complex relief and refractive designs, and then consider the whole process, which took months and in some cases years, nothing more than a particularly elaborate domestic exercise.

Our foremothers knew they were creating lasting works of art. Their knowing was in the several thousands of quilt designs they left to us, in the myriad of sophisticated design concepts and techniques they developed, and in the flawless, timeless artistry many achieved decade after decade.

Moreover, as with all other media, there is an easily recognizable historical continuum in American quilt design, which began with the creation of the earliest crude quilts. As women's needs, sources, and interests changed from region to region, the designs evolved into identifiable quilt genres. The beautiful scrap quilts of poor rural women, painstakingly pieced from the smallest, humblest scraps of fabric, such as recycled clothing and feedbags, were in total design opposition to the sophisticated appliqué quilts of the generally more affluent urban women who could pick and choose from bolts of lovely fabrics that were readily available. These more sophisticated quilts were also very different in composition from the dramatic, intensely colorful designs of Amish quilts, and these were again very distinct from the richly textured, lavishly embroidered silk and velvet parlor throws that became popular, especially in the eastern and coastal states, at the end of the nineteenth century. These elaborate throws were rather ostentatious in contrast to the simple geometric designs favored by Midwestern farm women and the intricate, carefully pieced quilts of the frugal New England women. The pretty, pastoral quilts of rural Appalachia and the Ozarks were very different from the bold, bright designs favored by the Western Prairie women. Certainly there was no one "American Quilt," and even today the meticulous appliqué quilts of Hawaiian women are easily differentiated from the almost psychedelically bright Star quilts of the Texas Panhandle.

Yet all these kinds of quilts were influential in determining a very large part of what we now recognize as an American design ethic. It is these geometric and appliqué designs, products of imaginative American women trying to stay in touch with their spiritual and aesthetic needs as women, that we see reflected in every area of American decorative and visual art today. Our foremothers' quilts were their art, and they were created for aesthetic, not just mundane purposes. It was not unusual for a quilt to be handed down through five generations of women in one family without ever being used.

Once barely acknowledged as a folk art form, quilts and their mode of assemblage have probably been partially responsible for the use of pieced design and pieced construction in every branch of American art, particularly in painting and graphics. Many modern American artists, whose work is reminiscent of the best pieced-fabric designs, did not simply pull their design concepts from the air. They were undoubtedly influenced by the pieced quilts that have been for so long part of basic American design and certainly part of our everyday culture.

Following the crest of the second wave of the women's movement in the 1960s, many women artists focused their attention on quiltmaking because of its almost exclusively female origins. They were concerned with women's artistic heritage and saw the possibilities of using cloth in the creation of a softer modern American art. Since there has always been a connection between women and cloth, it seemed natural that contemporary women's art should include fiber and cloth as viable media. With this in mind, many women artists have begun to explore the fine-art aspects of the cloth and fiber arts that their foremothers developed and to forge a link between their own futuristic quilts, hangings, and soft sculptures and the fabric and fiber arts heritage of women everywhere.

Unlike most traditional quilts, many contemporary quilts are not necessarily intended to be functional, but are intended instead, as is any fine art, to stimulate, to inspire, and to delight—whether as vertically hanging visual statements, as soft sculpture, as environments, or even as garments. The exquisite decorative quilts of the last century with their traditional repetitive designs have given way to the extraordinary quilt work of a new generation of women fabric artists who are exploring new design ethics with new forms, new intentions, and new techniques.

Many contemporary fabric artists feel that the traditional, functional role of a quilt as a bedcover has become irrelevant. For others, there is a delight in producing art that is useful as well as expressive. In either case, in the rediscovery of this art, contemporary fabric artists have deemed the potentially functional aspect to be generally irrelevant to the overall aesthetic value. Whether one is assembling a quilt or painting a canvas the motivation is the same: to stir the senses.

Today, more than ever, art functions to help us add greater meaning to our lives, reflecting the ways we respond to each other and to the environment in an increasingly anonymous, technocratic culture. In this sense the quilts and other fabric arts represented in this collection are true to art, as well as to American design traditions and culture. These quilts, hangings, and multidimensional pieces reflect our life-style in their unique forms and functions, in their use of textile media mixing, in their manipulation of lines and angles, in their use of light and textural interplays, in their startling use of graphic, photographic, and soft-sculpture techniques, in their invention of bold, new designs, and in their themes, which speak to us of the lives we live now. The fabric artists whose works are included here have for the most part laid aside the repetitive geometric designs of

the past and moved on to more innovative, personal designs, which emerge from the phenomena that, as part of modern culture, have affected us all: media, technology, ecology, politics, dreams, myths, visions, symbols, our roots in the past, and, finally, our hopes and expectations for the future.

By creating abstract, contemplative, and figurative pieces, by utilizing chromatics, textures, and graphic, photographic, and light effects, by investigating the spatial possibilities and limits of linear, geometric, and free forms, and by fitting many relevant traditional quiltmaking techniques to their needs, interests, and perspectives as artists and as women, the fabric artists represented in this collection have set a softer, more humanistic direction for all contemporary art.

PATTIE CHASE

ACKNOWLEDGMENTS

We want to thank all the people who took part in one way or another in the creation of this book, particularly, the women artists involved, who shared with us not only their work but their many aesthetic perspectives as well. That sharing and their enthusiasm about this project is the very heart of this book.

Special thanks to: Susan Hoffman for generously providing us with transparencies of Molly Upton's work and some information about it; Mr. and Mrs. Gordon Upton for so kindly allowing us to reproduce the work.

Many people went out of their way to be of help to us on so many occasions: Cynthia Nemser, *Feminist Art Journal;* Ruth Tanenhaus, Museum of Contemporary Crafts of the American Crafts Council; Laura Miller, Boston Society of Arts and Crafts; Andrew Stasik, Pratt Graphics Center; Steve Zuckerman, Sans Regret Gallery; Kornblee Gallery; The Ohio Building Authority; Marshall Field and Company.

The photographers Adeline Alex, Laura Blacklow, Peggy McMahon, Russell Windman, and Clark Quin helped us out on many occasions.

Over and over again friends helped us with the more tedious and often trying tasks that are so much a part of assembling a book. For aid, comfort, and so many favors at the very last minute, thanks to: Linda Brown, Susan Diesenhouse, Joe Ruggiero, Maria Barbarino, Kathleen Fitzgerald, Ellen Harrison, Luanne Benshimol, Carol Beckwith, Mitchell Hezlin, Leslie Gold, Lynn Gail, Carol Franko, Geoffrey Gunn, Chris McKay, Karen Peters, Susan Anway, Cheryl Williams, and especially to Radka Donnell, Muriel Harmon, and Libbett Cone, whose knowledge, generosity, and support made so much difference.

We are, of course, most grateful to our very kind editor, Cyril I. Nelson, whose help was invaluable.

ARTISTS' COMMENTS

LINDA ABRAMS: "When I was recuperating from an illness five years ago, I became bored one day and started sewing together velvet and satin ribbons I had lying around. Soon I was cutting up my velvet bathrobe and an old fur coat to make my first quilt. Since then I've been making quilts and soft sculpture incorporating velvets, satins, furs, rhinestones, and feathers. Birds and flowers are my main theme, which work to create a feeling of exotic sensuality."

AGUSTA AGUSTSSON: "*Colorado* was the first square of a quilt of memories, which is as yet unfinished, and which includes *Berkshires by Moonlight*, and *Puerto Rico*. I had been back-packing uphill and through the woods in Colorado, and suddenly there was a huge open meadow. The open space seemed to define all the surroundings. The sun shone on the grass, making it look like water. The mountains looked like mountains instead of tree-encrusted obstacles!"

CAROL BECKWITH: "In *Dreams of Kenya* I am sleeping in the forest with African animals surrounding me—snakes, tortoises, chameleons, fish, birds, small crocodiles—and an occasional Kenyan banana. In one dream, I become brown-skinned and have real African hair. In another my shadow lies next to me and appears to be almost human.

"*Ushikapo Shikamana* depicts the traditional eighteenth-century Swahili wedding scene on the island of Lamu, Kenya. The veiled and canopied wedding bed, the caned mahogany throne chair, the silk dolls used to decorate the walls, the crossed fans on the *ulili* bench in front of the bed are all part of the decor of the eighteenth-century wedding room."

HELEN BITAR: "Mount Hood hangs out my bedroom window. I look to see if it is visible every day, and when it is I look at it often in a day. It changes and has a different feeling through the day and early evening. What started the grand feeling I felt for the mountain was waking up before the sun came up, to see the flat, patterned, mountain shape in dark colors. Often the sky would appear red in the background. I wanted the quilt to reflect morning and early evening, when the moon often rises near the mountain."

LAURA BLACKLOW: "The process I used to print the image of myself, sleeping, onto cloth is called blueprinting, or the making of cyanotypes. The process is similar to one used to make architects' blueprints, except light-sensitive solution is applied to cloth instead of paper, and photographic negatives are used. The quilt's center image is an all-night exposure of myself sleeping. The idea developed from an interest in understanding my own dreams and from reading Carl Jung."

BONNIE P. BOUDRA: "I want the humor and ingenuous nature of the piece to come across as this quilt breaks with the tradition of flat quilts to form a six-foot ear of corn. The cob is biscuit quilted and the husk is machine quilted."

KAREN BRADFORD: "The first of the dolls I made was made as a present. They grew from there into portraits and ideas. They are more like large pillows than the usual doll with arms and legs. I included lots of fabric and fiber techniques: the hooked hair, fabric appliqué, and so on. I like the dolls because I like making art you can hug."

KAREN BRADFORD: "I love the idea of making something beautiful out of scraps and discards. It is a real challenge to work with the given: colors and textures that already exist and can't be mixed in a jar; hand-me-down pieces that one might not necessarily have chosen otherwise. It is exciting to put these things together in a way that is unique and original. As well, there is a more immediate, spontaneous response to work in fabric. People seem to find it less intimidating. The viewer comes to the work carrying less intellectual baggage, learned from critics who imply that art automatically means painting."

EVELYN BRENNER: "My intention is to unite a contemporary painting style with the folk tradition. I approach each wall hanging as I would a painting with its disciplines of space and color. Each area of a work must speak for itself, and all must be in harmony. Ideally, the finished work should unite quality of crafting with beauty of conception.

"My theme is the celebration of woman: woman as mother, sister, harlequin, clown, priestess—joyous, contemplative, mysterious—but always strong. I love women of all ages, times, locations, and occupations. When I work I become part of them, and when I am done with a piece I hate to say good-bye."

NANCY BRITTON: "I find a tremendous satisfaction and continuous enjoyment in designing and constructing, living with, and using something that I have created. That is why I continue to produce utilitarian objects, along with sculptural art objects. I find textiles an extremely versatile medium. The range of techniques lends itself to two-dimensional processes, such as printing, and surface design, and to three-dimensional surfaces, forms, and freestanding structures."

SHIRLEY BRITTON: "Inspiration for the pumpkin came after cutting a real pumpkin to reveal an inner fairyland. Interpreting this in fabric captured this moment: the pith of the pumpkin dripping with tiny crystal beads of moisture, inner walls of organzalike transparency, machine-stitched seeds, ready to grab by the handfuls."

KATHLEEN CARACCIO: "*Diamond in a Square* is a personally satisfying composition, for it allowed me to use a longtime avocation (sewing) with current methods of etching and engraving. The use of the piecework formula, as it is capable of infinite enlargement, gives the work a vast, spatial effect, not usually available to an artist working on paper. The trapunto quilting, giving deep relief to the surface, is an extension from the print-making technique of embossment. The piece was envisioned with the two media in mind, and the image retains much of both throughout."

JEAN CARLSON: "My fabric illustrations came out of my interest in American Indian heritage, particularly folklore. Their method of storytelling and oral history made use of great imagery and symbolism, lending itself well to illustration. Although I illustrate through fabric art, the process is very sculptural. It is a physical manipulation of fabric, building layers, adding, taking away, phasing, pulling, juggling textures and colors, until the right placement presents itself. The process has a life of its own; you just cannot get in its way."

DIANE CASTELLAN: "In my work I deal with fabric as a fine art. It is important to me that contemporary fabric art be viewed as art rather than as craft. In the execution of my pieces I deal with as many problems and concepts as a painter or sculptor."

PATTIE CHASE: "I love the idea of people wearing fantastic garments all the time. It reflects a joy in everyday living and celebrates the body as a moving surface for the display of art. In that sense, it takes art into the streets and out of the limited environment of a museum or gallery. In this case, the cloak is a statement about women's art. Since it is customary for women's art to be ignored, it amused me to design a deliberately spectacular visual surface that would be literally *impossible* to ignore."

SAS COLBY: "As an artist I have always turned to fabric for expression; the colors and tactile qualities, threads hanging, loose ends, textures, combination of patterns, all delight me. I am completely at home with fabric in a way I've never been with paint and canvas. The stitching process probably keeps me sane. I can do the most tedious handwork and feel very peaceful. Something chemical takes place in my body."

SUZANNE DERRER: "I have been working with fabric one way or another for the last twelve years. I find it an intrinsically pleasing medium to work with, and it gives me admittance to a heritage of women working with fabric that is very old. I have always been interested in the natural world. I am very attracted to the forms and patterns found in nature, and especially fascinated with camouflage and mimicry."

RADKA DONNELL: "I arrange the pretorn or precut strips, sometimes from the inside out, and sometimes from the outside edge of the quilt in. I keep going around it, moving around a lot, viewing it from above or sitting down. The design of the top interests me more than the pattern of the quilting. I want my quilts to be resilient and machine washable, and, therefore, I have them machine quilted by Claire Mielke. After a bunch of stripe quilts, I usually make a couple of geometric quilts to keep in touch with the basic problems of organization, on a conscious level.

"While I was a painter I never managed to get so literally 'inside' my work, only to get so messy that I spent a longer time getting cleaned up than painting, which thus got to be another kind of housework. But when I started piecing my quilts, I did not have to retire, away from my family and friends, but stayed in the midst of them. My neighbors and their children and dogs all walked through sometimes and hung around. I could share my joy in the making as it was happening and accepted advice from my daughters and their friends. This made my relationship generally more direct and more open and gave me confidence that I would tackle other parts of my life in a similar way."

JAN DUBINSKY: "*The Island* was designed as a child-sized dream space. I made *The Island* in pieces. First, the trees, then the sunset, then a few of the bigger waves. Then I mounted the trees on a plywood base and made the shape of the island itself. So many of the parts I like best—the waterfall, the beach, the rainbow, the muddy hillside. Each section grew slowly by itself—sometimes connected to an-other piece already finished, sometimes not. I think that art should have a practical side, so the top detaches for cleaning."

LEE FARRINGTON: "My work is an exploration of my personal images. I'm fascinated by myths, fairy tales, and dreams. I like the very simple and direct symbols that we use to encompass complex struggles and awakenings in our psyches."

LESLIE FULLER: "I am impressed by the need to tune our existence on this planet by balancing the active and the passive aspects in our daily lives. Creating bedclothes that deal with the sensitivity of one's health and habits, by experimenting with archetypal images to protect the dreamer, is my intention. I create landscapes to leave your body safely under, creating a center for easy return. I like creating the wedding quilt and the fertility blanket, wrapping warmth and philosophy into the routine of bed."

SUSAN FULMER: "I was dissatisfied with flat, two-dimensional form, and through the influence of a fabric-artist friend, I have been exploring a softer, more personal imagery with fabric and appliqué. I had been working with painting and graphics, but fabric seemed a more natural extension of myself."

ANN GATI: "In this piece black and silver is used in such a way as to depict coldness, aloneness, a kind of suffering. The woman holds a print of *Guernica* by Picasso, a large public statement about the same kind of suffering."

BETSY GROB GIBERSON: "I work with cloth because when I work with cloth I am in charge. It feels good to work in this manner. Nothing gets in the way of what I want to say. Cloth fits my rhythm."

JUDITH STEELE GOETEMANN: "*The Lady with the Unicorn* was inspired by the famous set of early sixteenth-century tapestries housed in the Cluny Museum in Paris. Each hanging depicts a beautifully gowned and bejeweled lady, against a rich, rose-red background decorated with elaborately designed flowers and animals. She is flanked by a lion, symbolizing strength and nobility, and a white unicorn, the representative, in medieval imagery, of chastity and purity."

SUSAN GOFSTEIN: "Every kind of cloth—stuffed, stretched, or draped—has such an inherent appeal and sensuality that it takes little work to make an attractive piece of work. For me the challenge lies in going beyond 'pretty' and trying to detour the merely bizarre. My pieces were attempts to create the proper graphic structures of texture, color, and weight, in which my narratives and anecdotes could live."

GWEN-LIN GOO: "I am not tied to any one material, but to many materials. I am tied to my ideas. Ideas determine the materials and techniques needed to execute the piece. From 1971 to 1974 I worked on a series of lip pieces that evolved—from a need to work with the translucent quality of plastic (which was then vacuum formed) to silk-screening on clear plastic, then vacuum formed; to a need to see the form cast in a flexible polyurethane foam; to then quilting the form with Quiana."

SUSAN HOFFMAN: "I see my work as being about relationships: relationships between the individual and the whole; between extremes such as hard and soft, the precise versus the indistinct, and so on. Many of these qualities are inherent in the quilting medium itself. There are all the individual pieces, each with its own character and separate life, and the whole that results in their interaction and joining with each other.

"Molly Upton and I decided that we would do a series of quilted tapestries. With each of us separately working out a piece on the agreed-upon theme, the two quilted tapestries made a pair, so we came to call the series the *Pair Collection*. The initial idea behind the third pair was plants, but as *Greek* and *Moonlit* progressed, we became occupied with the atmosphere and space within which the plants were to grow. We both found ourselves creating a space where there was a merging of interior and exterior. In both *Greek* and *Moonlit*, the boundary between indoors and outdoors is left open."

SANDRA HUMBERSON: "I have found that I can combine my sewing abilities and my love of detail and fabric with my interest in painting and drawing through the use of the silk-screen. By quilting, I can create sculptural pieces. I am interested in all levels of complexity, both physical and psychological. I often deal, in my work, with combinations of opposites, such as hard and soft, shiny and dull, organic and geometric. My pieces are conceived with the thought that I am making something for myself. I try to make some of my fantasies realities."

ANN HUTCHINSON: "When I start a piece, the stuff inside comes out easily. I draw boundaries around it by setting myself compositional, color, or technical tasks. By limiting an infinite thing, I am never at a loss for inspiration. In each piece a fraction of the initial rush is caught. This is often frustrating, and I go back to try to get more into the next piece."

KAREN KATZ: "There is a rich, sensuous experience I get from working with fabric that does not exist with any other medium. It is warm, flexible, and seems to absorb energy. Fabric is so personal! Each fabric has a personality. Satin is cool and glamorous, velvet is regal, cotton is natural and earthy."

JODY KLEIN: "Some ideas form themselves in two dimensions while others are visualized as three-dimensional objects. In both I am assembling, sorting, and combining. Large-scale sculptures such as the *Star Galaxy* entail special problems and special delights in which the fabric work is created as an architectural presence. The juxtaposition of hard and soft, dull and shiny surfaces makes an interesting visual impact on the people moving through the space; and while, hopefully, maintaining an aesthetic identity of its own, the *Star Galaxy* becomes an integral part of the architectural environment."

JODY KLEIN: "The idea of repeated images, which forms my visual vocabulary, originates from my background as a printmaker and my love for traditional pieced quilts. I find that my natural inclination toward scavenging, collecting, and assembling objects, combined with the manipulation of fabrics,

using dyes, thread, and stuffing, is a very satisfying way of transforming these ideas into a two- and three-dimensional reality."

REBECCA SCOTT LACKMAN: "When you make quilts you start with the designs, fabric scraps, colors, and threads, in contrast to starting with an empty white canvas as you do in painting. In quiltmaking, everything is already there just waiting to be put together. Starting with a pile of materials, I'm gently guided from there. With each piece the process is clearer, and it becomes easier to surrender the role of director and to be directed."

ALICE WHITMAN LEEDS: "As an artist I have tried to affirm my solidarity with working-class women by selecting a symbol of factory work, the sewing machine, as the tool by which I realize my work. . . . On the other hand, because I do not operate my sewing machine in the context of a factory, I have not been prevented from initiating action on my own and from defining my work as an investigation of alternative aesthetic possibilities of stitching by machine."

MEREDITH LIGHTBOWN: "My intention was to bring together two creative media, quiltmaking and graphic design, where they shared the common denominator of being created, built, and shaped on a structured system. It was a way of applying the professional side of my creative self to something of simple, utilitarian use."

TANA KRIZOVA LIZON: "I am very much influenced by the folk art of my native Czechoslovakia—weaving, costume, embroidery, wood-carving, and some of the architecture. That is where my love of bright colors originated. In this country, I became aware of the beautiful quilts, especially the quilts of the Amish, with their simple but powerful designs. I want to draw from these traditions in my work, and I would like my work to bring warmth and aesthetic feeling into people's environments, which are often so cold and colorless."

KAREN M. LUKAS: "My work is a constant exploration of chromatic interaction in a textile medium. My main objective is to present a surface that others might explore and, thus, ultimately share in the pleasure of the surface, the interactions, relationships, and elements involved on and in it."

BARBARA MARCKS: "I love beautiful things—to make them, and to have them around me. Everyday items give more gratification if they are as lovely as possible. I make quilts to have some spirit in them and always to be a source of pleasure."

JOYCE MARQUESS: "All things, in life and in art, are in the process of change from one state to another. I try to capture a sense of time in my work by using gradations, progressions, continuity, and also by using the 'stopped moment,' preserving a point in time with images and reliquaries."

PAULA JO MEYERS: "The countercultural associations, as well as the sturdy, long-lasting beauty of 100-percent cotton denim inspired me to compose this quilt. The quilt is very personal and real for me, not only because I made it, but because so many people wore the cloth and gave it, through wearing, the beautiful faded blues that come from the natural proc-

esses of sun-fading and wear and tear. Indirectly, hundreds of people were involved in this quilt."

CINDY MIRACLE: "I began working with old photographs with the idea of using them as ghostly images from the past. I needed a surface I could manipulate and alter radically, and cloth seemed the logical solution. I found that by using obvious machine stitching and a contemporary approach to the overall design I could avoid the sentimental nostalgia and strengthen the visual result, also playing the old against the new. I think of my stitching as lines, and using these lines, along with the juxtaposition of colors in the fabric and the contrasting textures of the materials, I can heighten this spatial illusion."

MARY ELLEN MOSCARDELLI: "Much of my inspiration comes from a strong fascination with things that float, fly, and gracefully move through space—clouds, falling leaves, creatures of the air."

JAN MOSEMAN: "When I began to express personal attitudes and experiences in textile media, I immediately was inclined to put pretty pictures on pillows. Part of the appeal of the pillow lay in its functional potential. I enjoyed the idea of making a useful item that would express something personal. Statement and image would become part of the user's perception in the course of everyday life."

JAN MOSEMAN: "Cloth is exceptionally appealing to me for its malleability and the way it can change its impact, from being flat and limp to being puffed up and obtrusive. It is valuable for its variety of surface sheens and textures. The traditional ways of embellishing cloth—embroidery, quilting, appliqué—are not only visually rich, in altering surface texture and color, but also enhance tactile properties."

SHARON MYERS: "Today's fabrics are glorious. Sometimes I just stand in my studio and bathe in the textures and colors. Then I have a chance to play with them, combining luscious colors and designs until they sing in perfect harmony."

RISË NAGIN: "I consider the making of contemporary quilts to be a continuation of the tradition of quiltmaking in America in much the same way that musicians such as Bob Dylan have gone back to earlier forms of traditional American folk music and given them a newer, contemporary form."

CYNTHIA NIXON: "I love the tactile qualities of the fabric I work with. I also love the attention to detail and craft that fabric offers, while still allowing line drawing and the use of rich color. While the imagery is the most important element in the piece, it is important to me that the pieces be objects with a life of their own. Because of the stuffing and quilting, they cast shadows. Unlike paintings on canvas, they are touchable and made from familiar materials."

MARILYN R. PAPPAS: "The central intent of my work has focused on the problem of forcing the viewer, through formal means, to accept the most diverse objects as having a particular coherence, caused by their juxtaposition within a new totality. Visual deliberations about color, shape, line, and texture, as well as a continuing interest in imaginative invention, and in the use of 'found' media have been my chief concerns."

SHEILA PEREZ: "My works evolve from a single concept. The concept is usually related to direct experience. I started using fabric instead of paint because I was working with transitions, and the block format of a quilt construction lent itself very well to my ideas. Painting had become limiting, so I began to stuff my surfaces."

JOAN A. PETERS: "I take up needle, thread, and fabric in celebration of my perceptions of the natural world and my own daytime fantasies and nighttime dreams. My choice of working in fabric probably is rooted in an age-old women's tradition. I learned to sew from my mother, as she in her turn had learned from her mother. In the process of working through a piece, I find myself entering a personal state of grace. I think that my approach to my work is of an emotional and a sensual nature."

FELICE REGAN: "*Cacti* began as a desert quilt. When I pinned the shapes to a wall to observe the progress, the shadows and negative spaces became an integral, visual part of the piece. The wall itself became important, for its flat unlimited white surface. The work became a sculpture and remained so."

WENDY ROSS: "This is my 'sexist' quilt and sarcastically comments on the unreal essential qualities of an *American Beauty*. Thus the title. Like Andy Warhol's Coke bottle, she is a mass-produced item. Fabric is synthetic and the quilt is machine appliquéd and quilted, as befits the subject. The beauties are completely utilitarian objects; not only do they collectively keep one warm at night, but each has a pocket in the crotch in which quarters, dollar bills, fingers, paperclips, and sundry items fit nicely."

MARION K. SIMS: "I'd personally rather have thirty-six Mona Lisa's tossed casually on the bed and willfully or unconsciously manipulate the fluid, fabric expressions than have the one-and-only *Gioconda* embalmed forever under glass, with armed guards, in the Louvre."

LENI SINGERMAN: "My quilts are diaries of places I have lived in and people I have known. I like to work with the idea of mirror effects in surroundings. Quilts provide a warmth, making a vehicle for expressing these ideas. In my work, the last quilt becomes an important design element for the one that follows."

JOY STOCKSDALE: "It is easy to focus my energy on the possibilities of inventing textile techniques. I am inspired to new approaches by modern fibers, fabrics, and the sewing machine. It is important to me to stay in touch with my sources of design—growth and change in nature is one aspect of it—and these things could be expressed in any medium. More than any other medium, textiles have a richness and quality that attract me."

MADELEINE THOMSON: "Every day I sew. / And while I sew I dream. / The dream I see I sew. / And what is sewn is the harvest / That sustains me."

MOLLY UPTON: "In *Construction*, the construction of the beams, which have a definite mass and weight, is such that each relies on the next to keep it in place, with the exception of the second horizontal beam from the top, which is in a completely detached situation—a kind of a floating pick-up stick. But since none of the beams has a distinct connection with the ground, I see the beams as floating in an atmosphere somewhere above solid ground. It somehow makes the viewer wonder where one's feet are in relation to the ground.

"I first conceived of *Torrid Dwelling* with no people— a riddle of a pile of rocks as a symbol of civilization. But starting with my piles of rocks, I felt the urge to create something where there was still a foundation, a place that was still habitable. Midway in making *Torrid Dwelling*, I included a couple of men and a chicken, as a conscious but hidden clue that the landscape could support man. But the irregular and often illogical juxtaposition of the 'stones' make it active and put it in motion, suggesting an impending change—even ruin."

CLARA WAINWRIGHT: "I think that there are a lot of reasons that women do things with fabric, more than men do. I think that women's sensibilities are much more oriented toward the sensuous qualities of cloth. That sensuous nature of fabric is important. Fabric is living and flexible, and you have to be responsive to it.

"My work has a lot of literary associations, more than visual ones. I love working with cloth in that way because of the endless possibilities and the biographical implications. For instance, when I am working with the fabrics I will think to myself: 'This fabric came from a dress I wore in 1945; and this came from a dress I wore in 1972; and this dress is my wedding dress, and the fact that I've ripped it to pieces is just wonderful.' I realize that these associations are a large part of what I'm doing."

WENDA F. VON WEISE: "I respond to texture, both visually and in a tactile sense. I love the feel of fabric when I'm working with it. This sensual perception of texture then enables me to experience the *illusion* of texture, as it is represented in a photograph. I can further heighten this awareness of texture by juxtaposing photographs, representing a wide range of textured objects—smooth, hard, and rough— to the soft, pliable texture of the fabric plane, via the photographic screen-printing process."

NANCY WRIGHT: "My quilts are a reflection of myself. Like me, they are practical, being warm and washable, and they are down to earth, depicting my friends and the world around me. I've never been much of a fantasy person, and being able to touch and manipulate the tactile medium of fabric appeals to something very basic and historical in me."

I. ABSTRACTS/IMAGES: THE NEW AMERICAN QUILTS

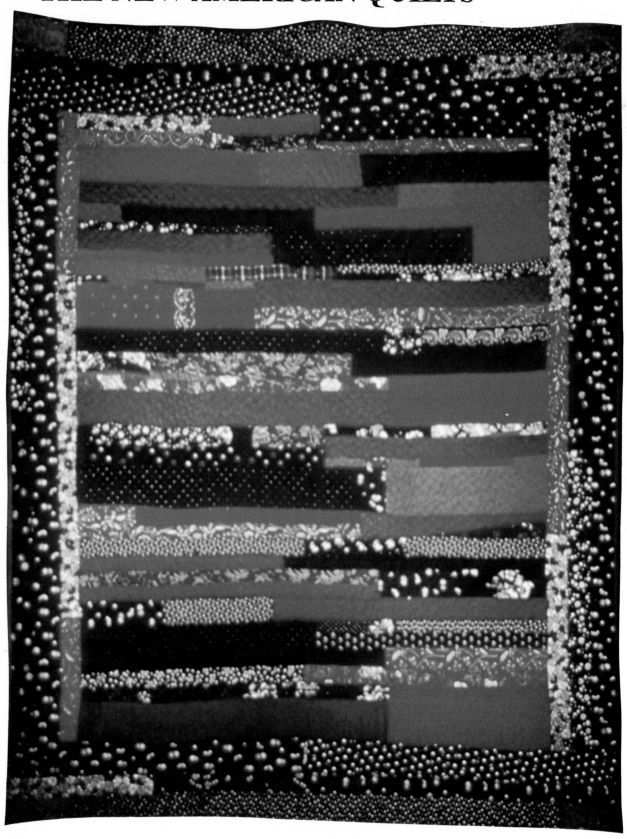

3 (above). *Great American Girl*, Radka Donnell, 1975. 72″ x 92″.
Cotton. Pieced and quilted. This quilt is made as a tribute to the
artist's daughter Julia Donnell. Photograph: Roswell Angier.

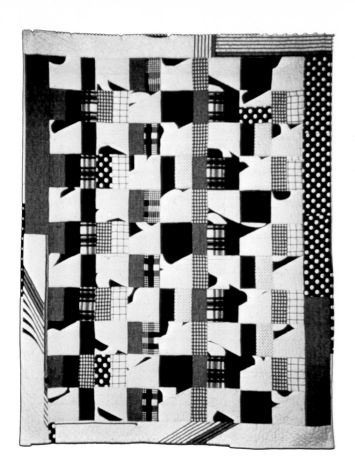

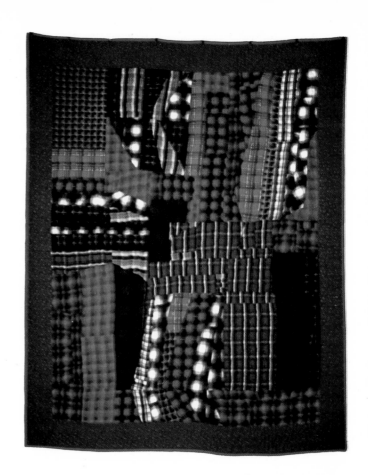

4 (above, left). *Both Sides of the Moon*, Radka Donnell, 1975. 82″ x 102″. Cotton. Pieced and quilted. This quilt is a fabric accolade to the artist's sister, for support and encouragement. Photograph: Roswell Angier. (Private collection)

5 (above, right). *Ale Liberation*, Radka Donnell, 1974. 72″ x 102″. Cotton and flannel. Pieced and quilted. Flannel shirts and glowing colors express the artist's very personal tribute to her former husband. Photograph: Roswell Angier. (Artist's collection)

6 (right). *Transatlantic Love*, Radka Donnell, 1976. 78″ x 80″. Cotton. Pieced and quilted. Love spanning a great distance is the theme of this quilt, with a literal jump across a continent and a corresponding jump in design. Photograph: Tresch & Wenger, Zurich. (Artist's collection)

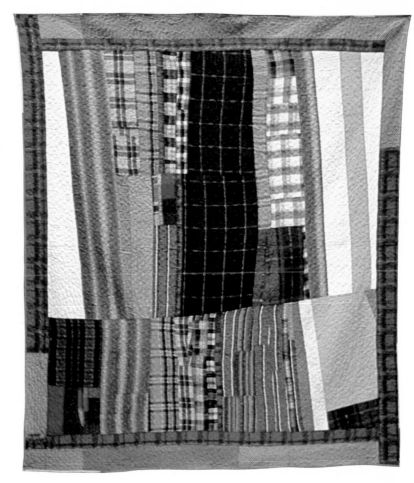

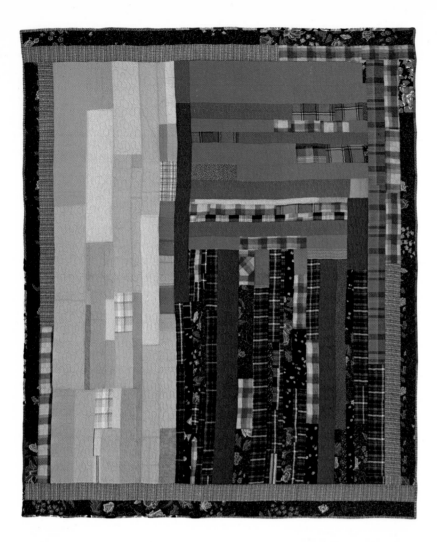

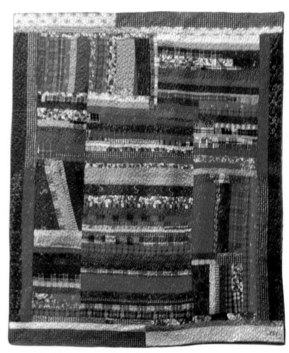

7 (left). *Skin of Spring*, Radka Donnell, 1977. 98″ x 72″. Cotton. Pieced and quilted. Self-renewal and reaching out were the artist's themes here, with her daughter Moira as the inspiration for the work. Photograph: Henzi AG., Bern. (Private collection)

8 (above, right). *Hopscotch*, Radka Donnell, 1976. 92″ x 102″. Cotton. Pieced and quilted. Full of joyful colors and movement, this was a wedding quilt for the artist's brother. Photograph: Mimi Dolbier. (Mitko and Elizabeth Zagoroff)

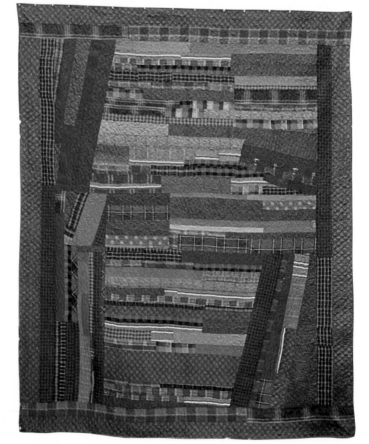

9 (right). *The River Siehl*, Radka Donnell, 1977. 82″ x 102″. Cotton. Pieced and quilted. The colors and the direction of the stripes were used to evoke the river. Photograph: Tresch & Wenger, Zurich. (Private collection)

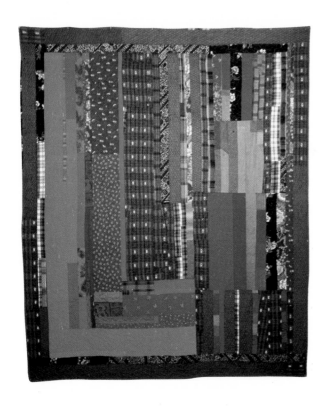

10 (left). *L for Love*, Radka Donnell, 1977. 88″ x 102″. Cotton. Pieced and quilted. The tension between the corners and the center of this quilt design suggested the letter *L*. Photograph: Peggy McMahon. (Sarah Osborn)

11 (right). *Julie's Quilt*, Radka Donnell, 1977. 80″ x 92″. Cotton. Pieced and quilted. A collision of verticals and horizontals was the formal challenge for the artist in this recent work. Photograph: Peggy McMahon. (Julia Donnell)

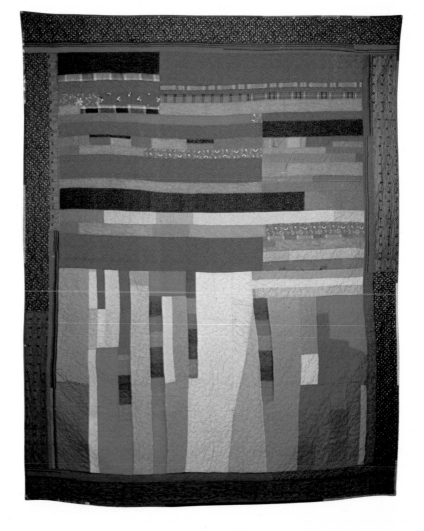

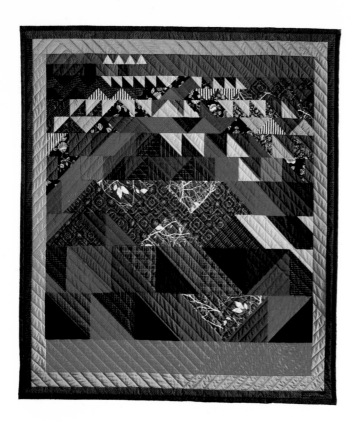

12 (left). *Invention in the Spirit of J. S. Bach,* Susan Hoffman, 1975. 91″ x 82″. Cotton. Pieced and quilted. The artist calls this piece a visual transposition of the spirit of the first movement of the Brandenburg Concerto #1. Photograph: Eeva-Inkeri. (Alexander C. Hoffman)

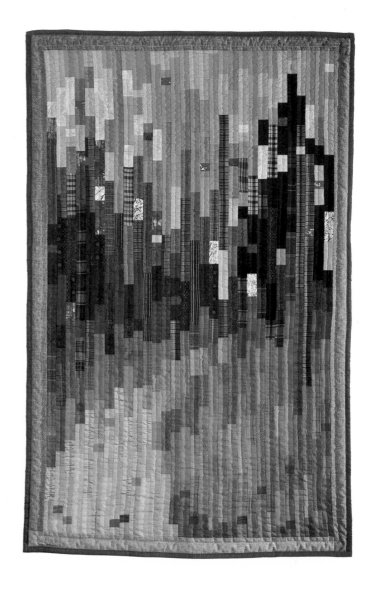

13 (right). *Last Leaves,* Susan Hoffman, 1976. 63″ x 41″. Cotton, wool, silk, linen, and cotton blends. Pieced and quilted. This quilt was conceived as the artist's response to the few last leaves that persistently cling to the otherwise bare branches in November. Photograph: Karla Tonella. (Private collection)

14 (below). *Coastline,* Susan Hoffman, 1975. 80″ x 241″; triptych. Cotton, cotton blends, wool, linen, and silk. Pieced and quilted. In each quilt, and in the triptych, the individual pieces determine the whole as much as the whole determines the pieces. Photograph: Robert Shankar. (Kornblee Gallery)

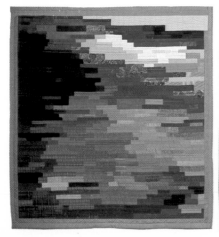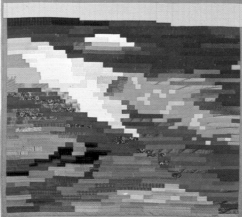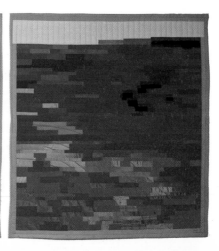

15 (right). *Greek*, Molly Upton, 1974. 92″ x 80″. Cotton, cotton blends, and wool. Pieced, appliquéd, and quilted. Part of a *Pair Collection* done in collaboration with quilt artist Susan Hoffman, this quilted tapestry reflects the artist's genius for creating perspective and the appropriate thematic atmosphere in her work. Photograph: Molly Upton. (Noëlle Warden King)

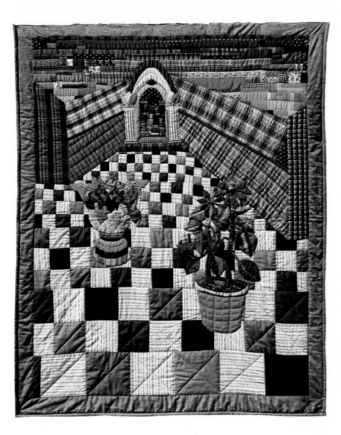

16 (below). *Moonlit*, Susan Hoffman, 1974. 99″ x 80″. Cotton, cotton blends, and wool. Pieced, appliquéd, quilted, and tufted. This quilt is part of a thematic *Pair Collection*, a collaboration between the artist and the late quilt artist Molly Upton. Photograph: Robert Shankar. (Renée S. Guest)

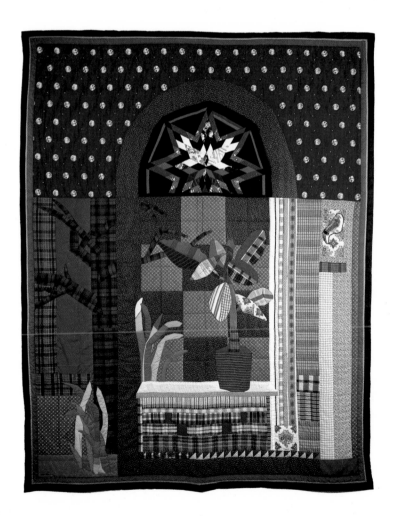

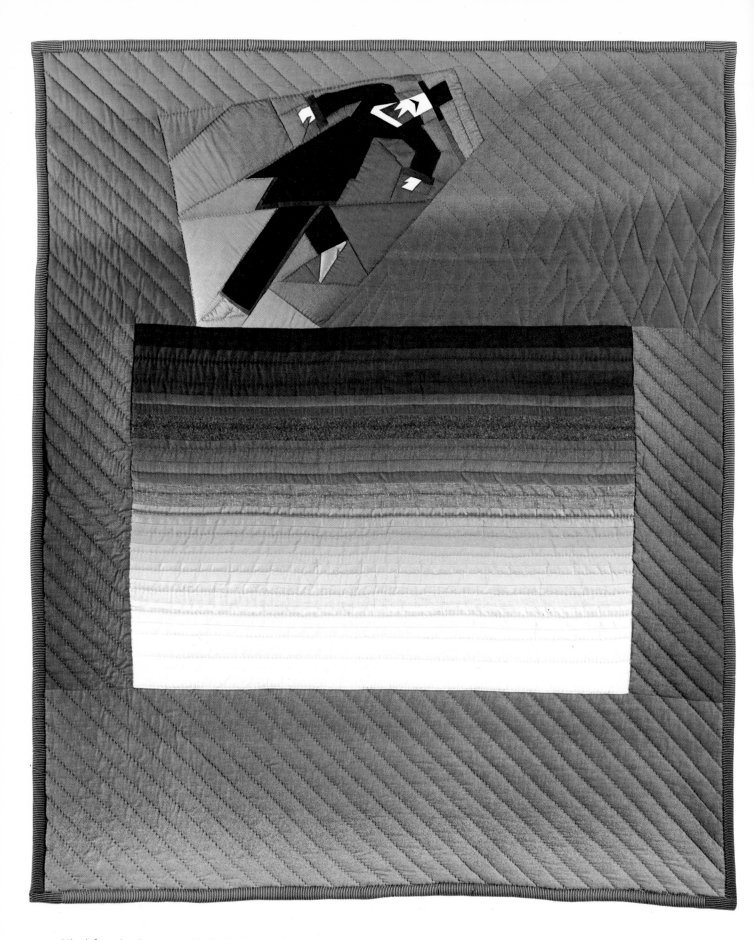

17 (above). *Overcoat*, Molly Upton, 1976. 54″ x 46″. Cotton. Pieced and quilted. The title of the piece is from Gogol's short story, "The Overcoat." The image of the man running is the artist's variation on the central figure of Lyonel Feininger's painting, *Street in Paris (Pink Sky)*. Photograph: Karla Tonella. (Private collection)

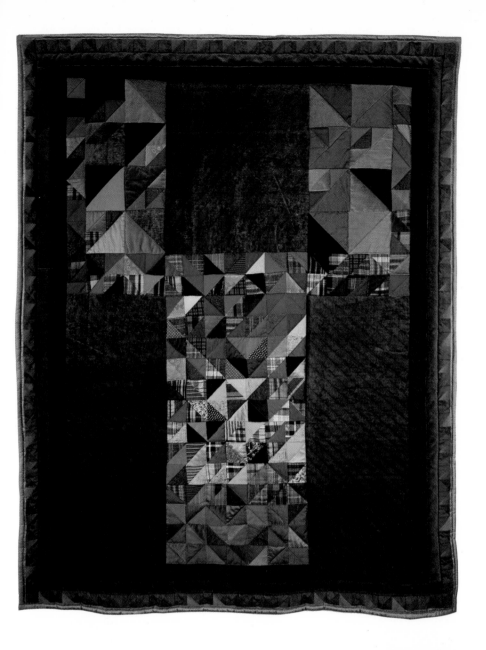

18 (above). *Symbol: Self-Portrait Without a Mirror,*
Molly Upton, 1976. 78″ x 65″. Cotton and wool. Pieced
and quilted. The starting point for this piece, an
autumn spent in New Hampshire, is expressed by the
falling triangles within the Y-shaped figure.
Photograph: Robert Shankar. (Private collection)

19 (right). *Construction,* Molly Upton, 1975.
80″ x 74″. Cotton. Pieced and quilted. Although at
first glance the beams seem to be solid and facing front,
there is an underlying riddle to the structures.
Photograph: Eeva-Inkeri. (Private collection)

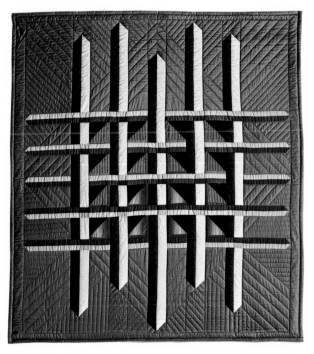

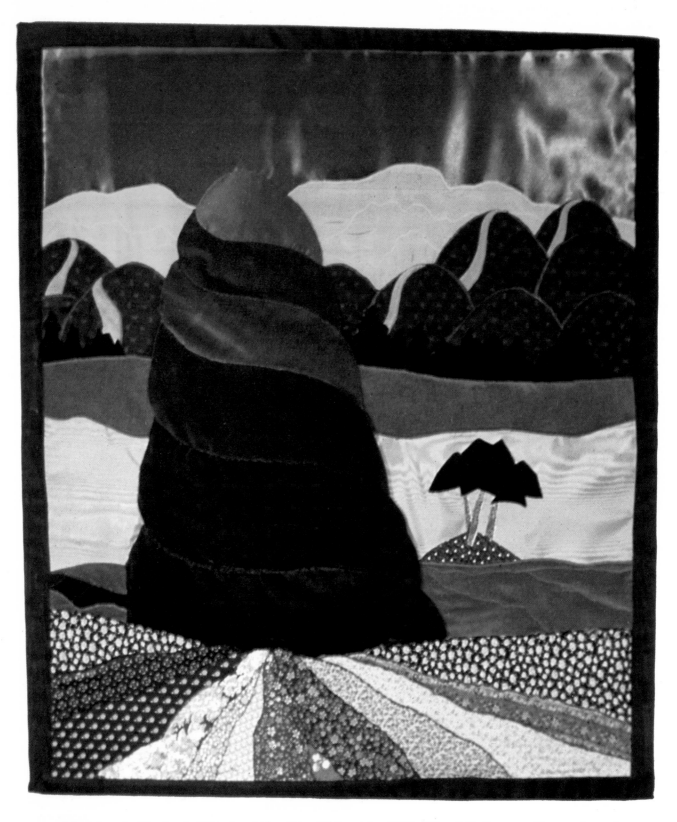

20 (above). *Elephant's Watering Hole,* Clara Wainwright, 1975. 30″ x 24″. Cotton, taffeta, satin, and velvet. Appliquéd (stretched on frame). The artist's use of old fabrics, some visibly affected by light and age, gives the hanging a nostalgic, dreamlike quality. Photograph: Andrew Wainwright. (Private collection)

21 (right). *Desperados,* Clara Wainwright, 1977. 63″ x 38″. Silk, velvet, cotton, taffeta, and scraps from a nineteenth-century sewing basket. Pieced and appliquéd. This is a crime fantasy inspired by the artist's frustration over fund raising for the arts. Photograph: Andrew Wainwright. (Artist's collection)

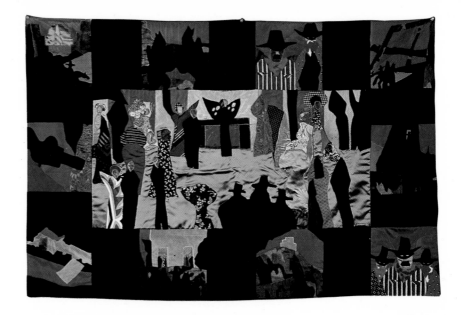

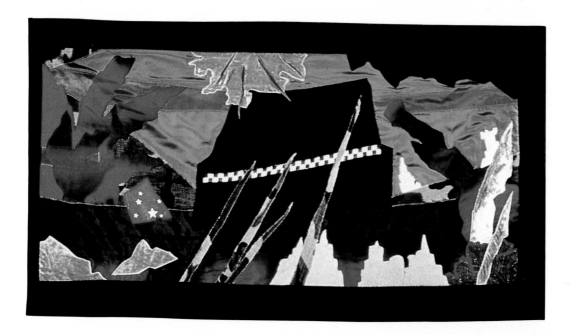

22 (above). *Deep Sea Sift,* Clara Wainwright, 1977. 20″ x 38″. Velvet, chintz, taffeta, camel's-hair, and camouflage cloth. Appliquéd. Old fabrics, with their inherent translucence, illuminate the colors in this piece and give it a shimmering, underwater quality. Photograph: Andrew Wainwright. (Artist's collection)

23 (right). *Apotheosis of Daikon,* Clara Wainwright, 1976. 36″ x 26″. Satin, velvet, taffeta, and faille. Pieced and appliquéd. This is the artist's celebration in fabric for the prolific growth of daikon radishes in the "baroque theatre" of lush vegetation that is her garden. Photograph: Andrew Wainwright. (Private collection)

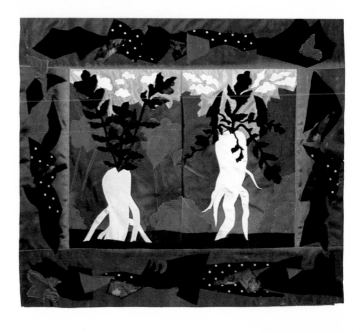

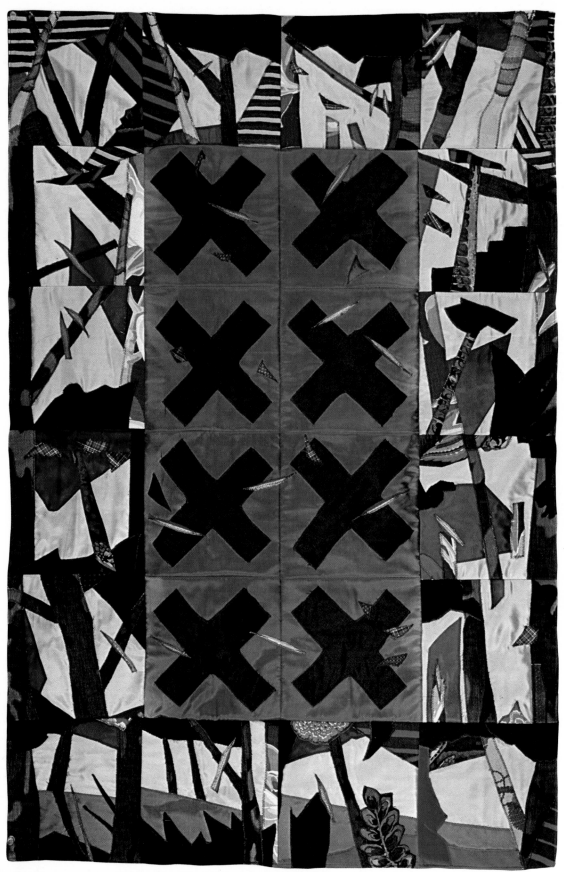

24 (above). *The Settling of Birds, Leaves and Ellipses,* Clara Wainwright, 1977. 55″ x 33″.
Taffeta, Finnish cotton, velvet, camouflage cloth, and ribbon. Pieced and appliquéd. The movement
in this piece evolved unintentionally during its creation, when a breeze blew the slender fabric
leaves in random patterns across the rest of the image. Photograph: Andrew Wainwright.
(Artist's collection)

25 (right). *The City and the World,* Clara Wainwright, 1977. 62″ x 32″. Linen, cotton, taffeta, silk, satin, and velvet. Pieced and appliquéd. *Flying Carpet* series. In this piece, the artist employs both unusual shapes and interesting fabrics to create the desired spatial image. Photograph: J. M. Snyder. (Artist's collection)

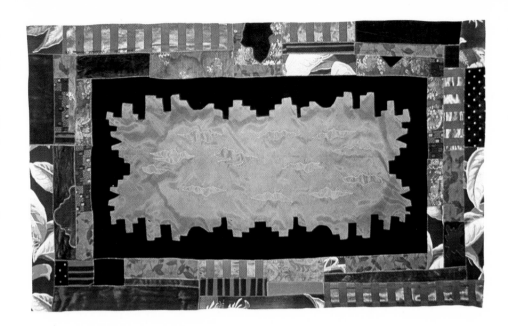

26 (below). *Wild Order of Castle Hill,* Clara Wainwright, 1976. 62″ x 32″. Wool, velvet, taffeta, linen, and cotton. Pieced and appliquéd. Another *Flying Carpet,* this piece evokes a spatial illusion and employs the use of richly textured fabrics. Photograph: J. M. Snyder. (Artist's collection)

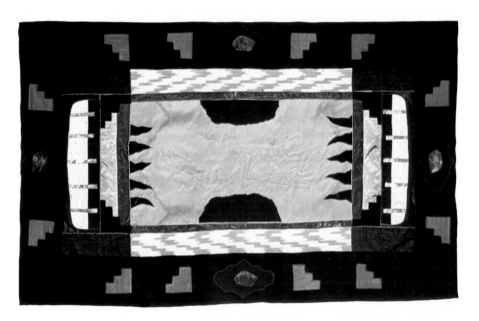

27 (right). *Isthmus,* Clara Wainwright, 1976. 55″ x 28″. Velvet, taffeta, and satin. Pieced and appliquéd. *Flying Carpet* series. The rich fabrics used to create this piece are an important element in the artist's depiction of exotic and wonderfully bizarre images and events. Photograph: J. M. Snyder. (Private collection)

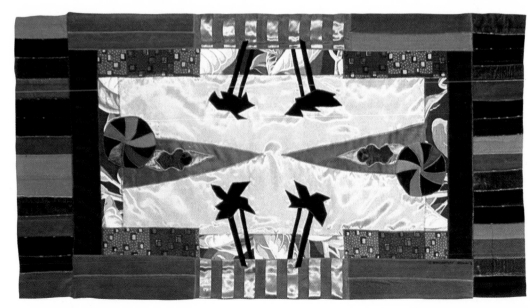

28 (right). *High over Arabian Space*, Clara Wainwright, 1976. 28″ x 53″. Cotton, velvet, taffeta, silk, and satin. Appliquéd. *Flying Carpet* series. In this last of the *Flying Carpet* series, the distance created by the design of the abstract landscape and the use of perspective suggest that the viewer is looking down from a great height. Photograph: Mimi Dolbier. (Private collection)

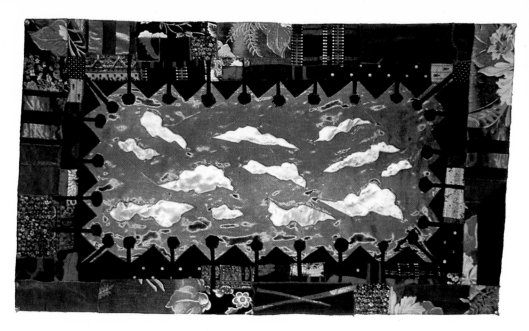

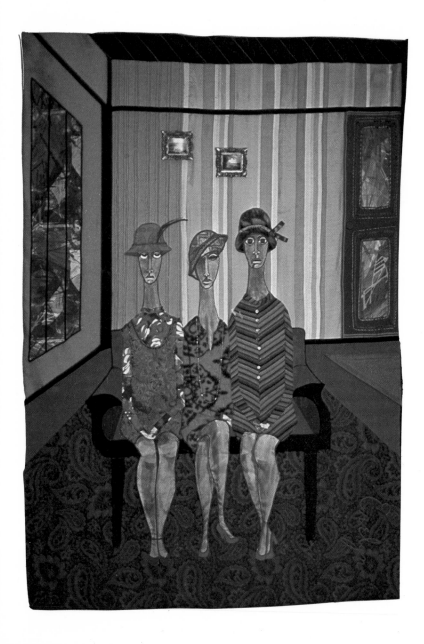

29 (left). *Just Waiting*, Evelyn Brenner, 1975. 70″ x 45″. Velvet, silk, and upholstery fabric. Appliquéd, glued, and stitched. The use of mixed media has much to do with the unique quality of this colorful collage tapestry. Photograph: Anthony Valez. (Private collection)

30 (opposite, above left). *Studio Portrait No. 1*, Evelyn Brenner, 1976. 66″ x 41″. Velvet, leather, beads, silk, embroidery threads, fringe, and paint. Appliquéd and painted. In this mixed-media piece, the contrast of the hand-painted silk faces with the heavier fabrics gives the figures a stylized yet very lifelike quality. Photograph: Anthony Valez. (Artist's collection)

31 (opposite, above right). *Studio Portrait No. 3*, Evelyn Brenner, 1976. 35″ x 53″. Velvet, lace, feathers, silk, and paint. Appliquéd and painted. Here, as in her other portraits, the artist has employed very elaborate embellishments to create a kind of Victorian nostalgia. Photograph: Anthony Valez. (Artist's collection)

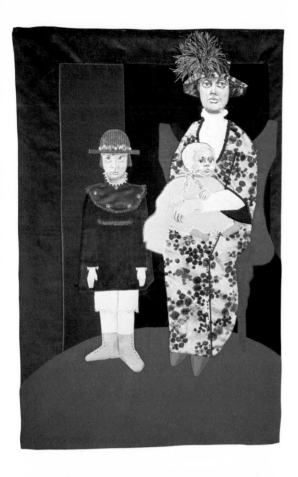

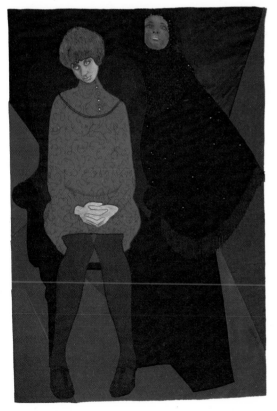

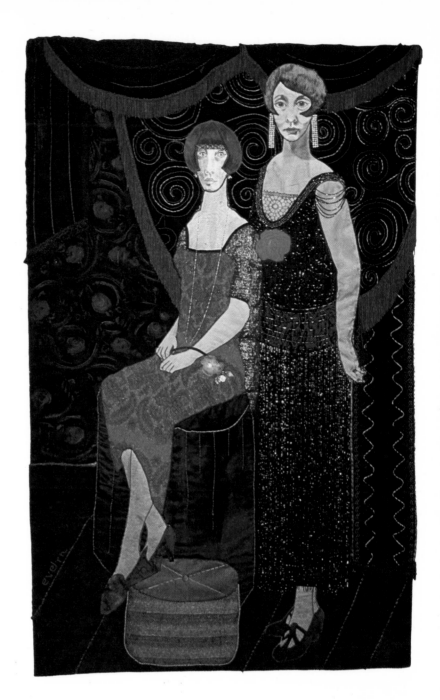

32 (left). *Daydream*. Evelyn Brenner, 1976. 48″ x 71″. Velvet, wool knit, silk, leather, sequins, fringe, and paint. Appliquéd, sewed, and painted. The theme of a young girl daydreaming of her older, more sophisticated, worldly self is the focus of this fabric collage. Photograph: Anthony Valez. (Artist's collection)

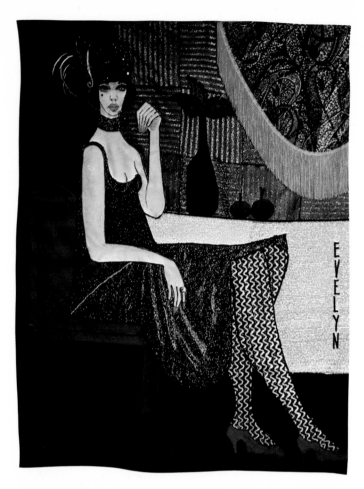

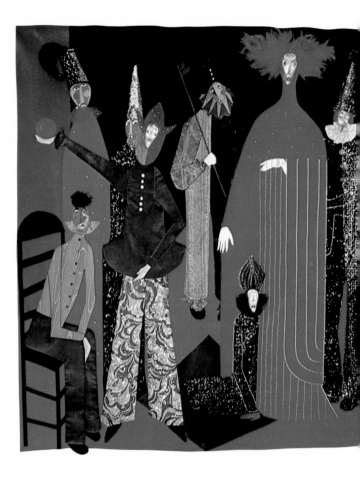

33 (above). *Flapper*, Evelyn Brenner, 1976. 42" x 56".
Velvet, sequins, and feathers. Appliquéd, glued, and stitched.
The gaudy fabric, sequins, and feathers help to evoke
the twenties' image that the artist intended. Photograph:
Anthony Valez. (Private collection)

34 (above, right). *Harlequin and Clowns*,
Evelyn Brenner, 1976. 68" x 78". Velvet,
sequins, assorted trimmings, clay faces
encased in gel. Appliquéd, glued, and
stitched. The elegant harlequin of the clown
world is pictured here, not as a buffoon,
but with the qualities of humanity,
and pathos. Photograph: Anthony Valez.
(Artist's collection)

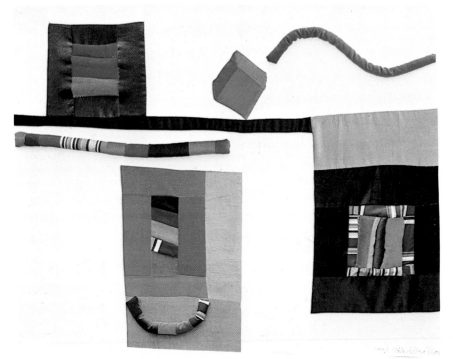

35 (left). *In Space*, Tana Krizova Lizon,
1977. 42" x 28". Corduroy. Appliquéd and
quilted. The combination of textures, the
movement of the forms, and the unique
overall shape give this piece strong impact.
Photograph: Jan Pucher. (Jan Pucher
Collection)

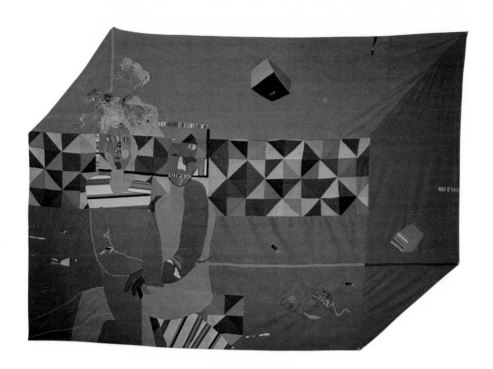

36 (above). *Toogether*, Tana Krizova Lizon, 1977. 82″ x 45″. Linen. Appliquéd. The unusual perspective in this piece adds an interesting dimension to the overall design. Photograph: Peter Lizon. (Artist's collection)

37 (right). *Woman*, Tana Krizova Lizon, 1976. 29″ x 22″. Linen. Appliquéd. There is much movement in this tongue-in-cheek piece; the combination of bright, colorful fabrics adds to the folk-art image. Photograph: Peter Lizon. (Boris Sevruk)

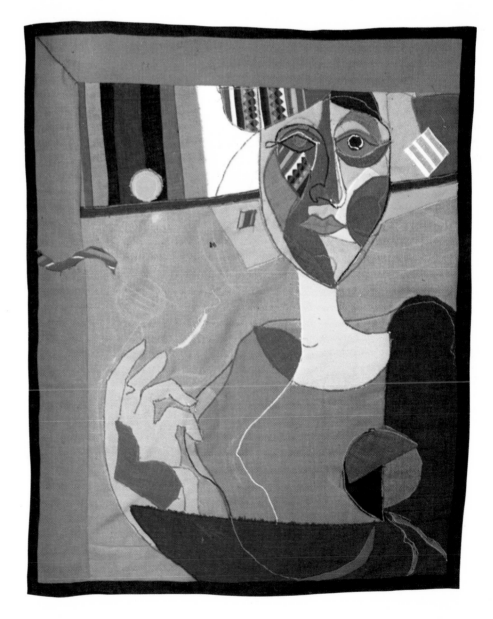

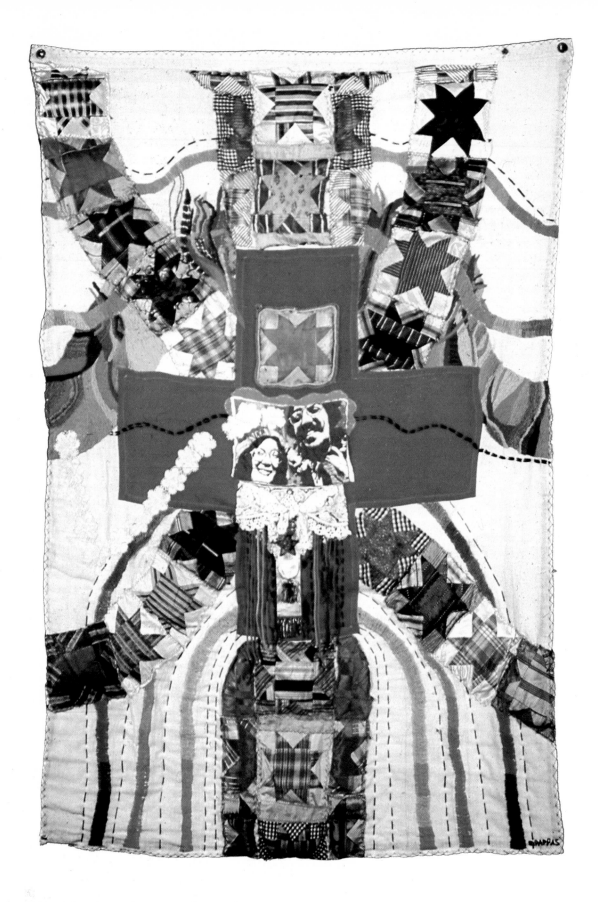

38 (above). *Red Cross Quilt*, Marilyn R. Pappas, 1973. 68″ x 46″. Old Red Cross flag, lace, fabrics, yarns, and old quilt pieces. Photo-silk-screened, quilted, appliquéd, and stitched. The artist's work is unique in incorporating memorabilia and found objects into a whole new visual totality. Photograph: David Read. (Artist's collection)

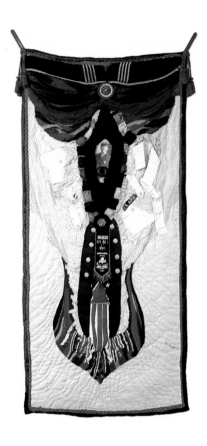

39 (left). *Memorial to War Heroes,* Marilyn R. Pappas, 1975. 68" x 32". Old photograph, parts of cloth objects, linen, yarns, and silk threads. Appliquéd and quilted. The hanging, with its Bicentennial theme, has a banner quality about it, which evokes the theme even more. Photograph: Greg Heins. (Artist's collection)

40 (below, left). *Pris' Attic,* Marilyn R. Pappas, 1973. 56" x 38". Old photograph, piece of antique biscuit quilting, pieces of cloth objects, yarns, ribbons, and tassels. Stitched, appliquéd, and quilted. There is a nostalgic quality in this hanging that comes from the imaginative use of so many found objects. Photograph: David Read. (Artist's collection)

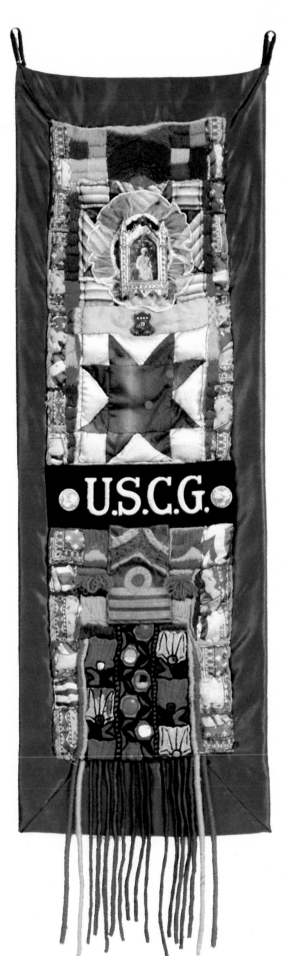

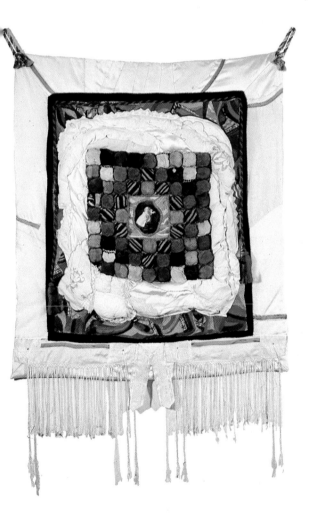

41 (right). *Stonington Lady,* Marilyn R. Pappas, 1973. 36" x 12". Old photograph, pieces of cloth objects, linen, satin, yarns, buttons, and an old quilt square. Appliquéd and quilted. The color and pattern relationships in this hanging give it strong visual definition. Photograph: Greg Heins. (Artist's collection)

42 (below). *Summer Quilt,* Barbara Marcks, 1975. 90″ x 90″. Cotton and cotton polyester. Appliquéd and quilted. The focus in this very large quilt is on the unusual abstract appliqué, which provides a startling visual transposition due to its interesting chromatics. Photograph: Russell Windman. (Artist's collection)

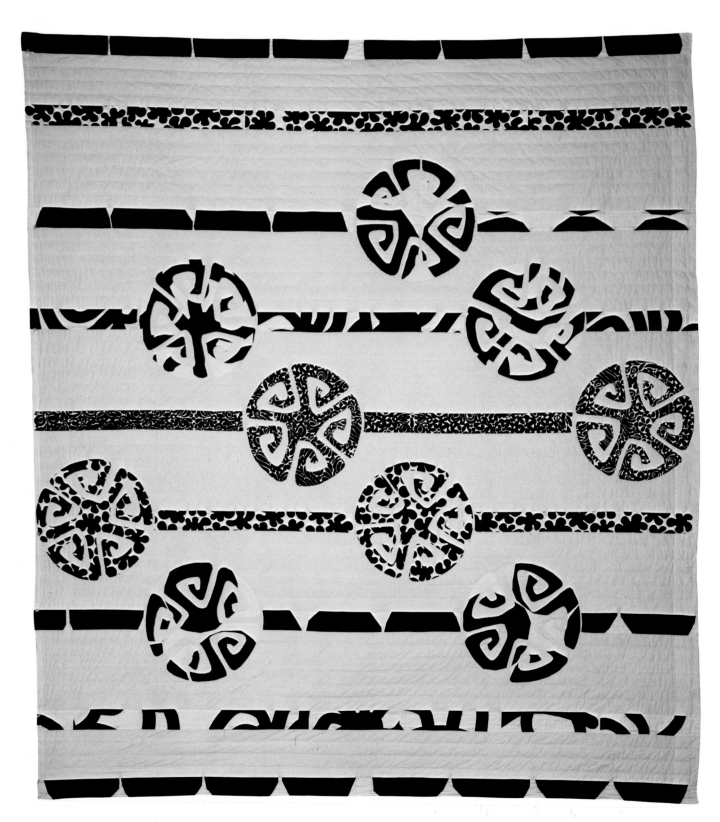

II. GRAPHIC, PHOTOGRAPHIC, AND BATIK QUILTS AND HANGINGS

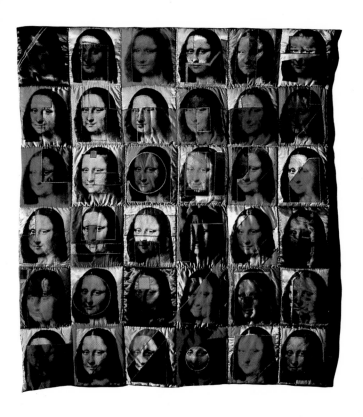

43 (left). *Mona Lisa*, Marion K. Sims, 1976. 64″ x 72″. Silk, satin, rayon, nylon, found pieces. Photo-silk-screened, pieced, appliquéd, quilted. This piece is one of a series representing the *Mona Lisa* with changed facial expressions; the artist has produced a hilarious and colorful quilted print by manipulating this well-known image. Photograph: Marion K. Sims. (Artist's collection)

44 (right). *Kneale Farm: Sunset*, Wenda F. von Weise, 1977. 79″ x 67″. Silk, photo-screenprinted with dye. Pieced and quilted. This is one of a series of works that included images of the Kneale farm in the late afternoon and at sundown. The image is overprinted in some areas for a more pronounced effect. Quilted by Trinity Congregational Church Quilters, Pepper Pike, Ohio. Photograph: Wenda F. von Weise. (Artist's collection)

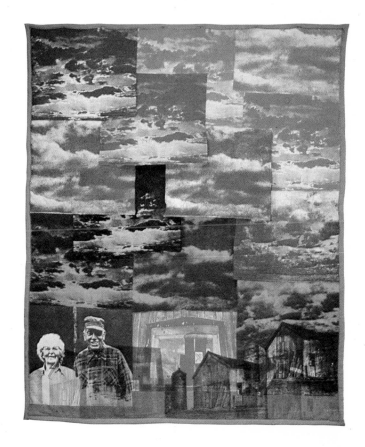

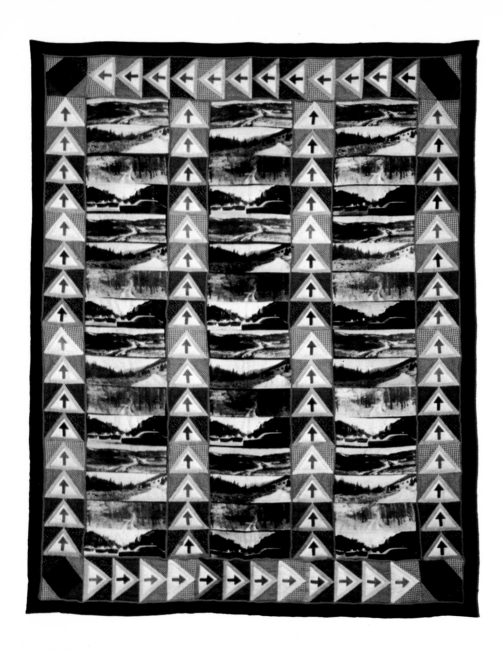

45 (left). *Wild Goose Chase*, Wenda F. von Weise, 1977. 76″ x 62″. Cotton, van Dyck printed (brown printed) direct photo on fabric. Pieced and quilted. In this contemporary version of the Wild Goose Chase design, the triangles are cut from cloth printed with photographs of signs from one-point perspective, so that they, too, form triangles. Quilted by Mrs. B. Braconovich. Photograph: Wenda F. von Weise. (Artist's collection)

46 (below, left). *Diamond in a Square*, Kathleen Caraccio, 1976. 76″ x 76″. Cotton and polyester. Relief printed, pieced, stuffed, and quilted. Traditional quilt design has been combined with modern hand printing, using etched zinc plates and engraved plastic plates, and with "rainbow" and "fade-out" inking techniques. Photograph: Scott Hyde. (Artist's collection)

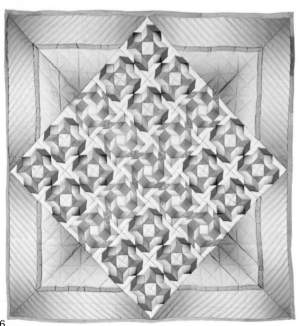

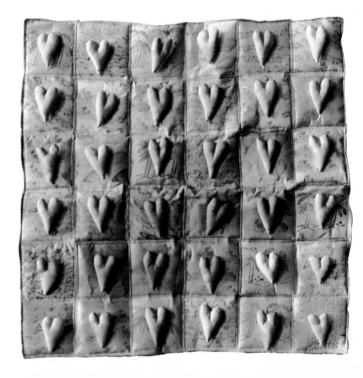

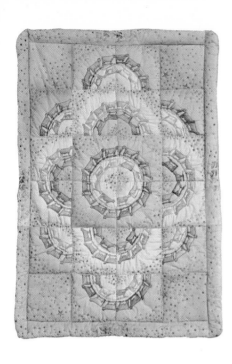

47 (opposite, below right). *Small Quilt of 3 Dozen Hearts,* Jody Klein, 1977. 30″ x 30″. Cotton and silk. Stamped and airbrushed. Each of the hearts was individually stamped, stuffed, and fastened to the blocks with monofilament attachers, giving the quilt an unusual dimension. Photograph: Jody Klein. (Artist's collection)

48 (left). *Cows Grazing in the Milky Way,* Jody Klein, 1977. 65″ x 44″. Cotton, unbleached muslin, and cotton sateen, airbrushed and rubber-stamped with Deca Dye. Pieced and stuffed. Based on a block pattern, which can vary the design according to how the blocks are placed, this particular variation forms a circular pattern. The airbrushing enhances the ethereal effect. Photograph: Jody Klein. (Artist's collection)

49 (below). *The Lady with the Unicorn,* Judith Steele Goetemann, 1976. 112″ x 126″. Procion-dyed cotton. Batiked, pieced, and quilted. Rich in symbolic imagery, the intense color and intricate patterns of the medieval tapestry translated beautifully into the batik medium. Quilted by St. Gertrude's Mission Group, St. Cloud, Minnesota. Photograph: Russell Windman. (Artist's collection)

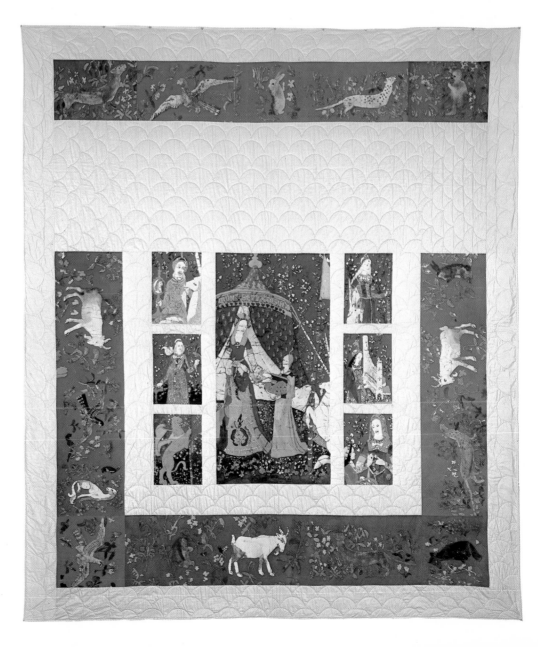

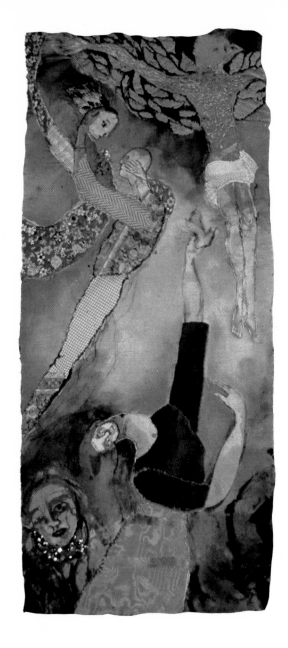

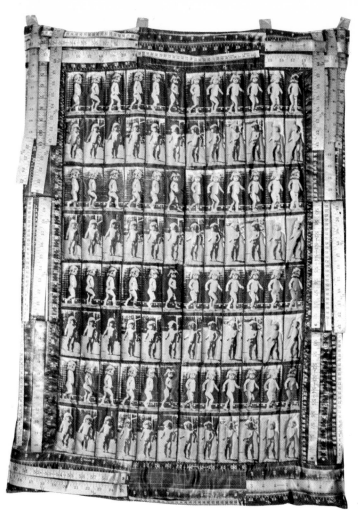

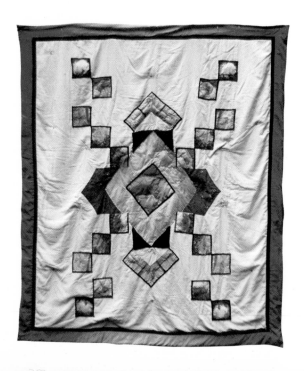

50 (above, left). Untitled tapestry, Susan Gofstein, 1972. 19″ x 15″. Felt, cotton, velveteen, and sequins. Batiked, painted, embroidered, appliquéd. This piece has a strong narrative quality and symbolic overtones, as well as a rich chromatic effect. Photograph: Alexander Rossner. (Private collction)

51 (below, left). *Dream Quilt*, Laura Blacklow, 1976. 80″ x 66″. Cotton, velvet, and ribbon trim. Blueprinted, appliquéd, pieced, and embroidered. A dream image was obtained by the use of photographs taken while the artist slept; they were then printed on cloth and assembled into a quilt. Photograph: Mimi Dolbier. (Arthur and Frances Blacklow)

52 (above, right). *Measured Steps: Baby Quilt,* Jan Moseman, 1976. 84″ x 60″. Millium, linen, felt, and adhesive. Photo-silk-screened, pieced, quilted, and appliquéd. The repetitive-action image of a child in motion, against the background of rulers and other measuring devices, creates an interesting juxtaposition of limitation and abandon. Photograph: Jan Moseman. (Artist's collection)

53 (opposite, above left). *Garrett County Blue Ribbon Quilt,* Sandra Humberson, 1974. 68″ x 90″. Cotton. Photo-silk-screened and quilted. The ground fabric for this piece was the artist's drop cloth, which had been used for three years in silk-screen printing. Images of family and friends were added to create a contemporary heirloom. Photograph: Sandra Humberson. (Ohio Building Authority)

54 (opposite, above right). Untitled quilt, Leni Singerman, 1976. 72″ x 52″. Muslin and flannel. Batiked, stitched, and quilted. This figurative batik quilt reflects the pleasures of bedding. Photograph: Mimi Dolbier. (Artist's collection)

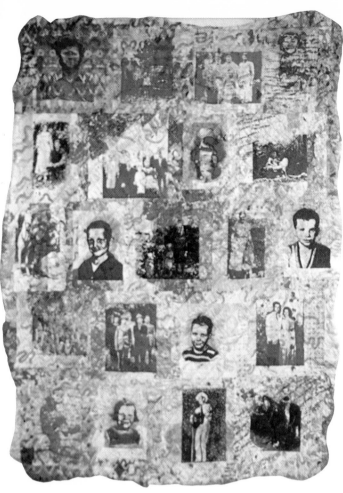

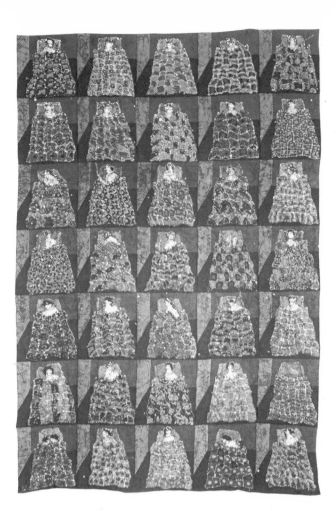

55 (below). *Clear Patterns on a Cloudy Sky*, Mary Ellen Moscardelli, 1975. 90″ x 60″. Velveteen and cotton. Dyed, pieced, and quilted. Fabric for this piece was carefully hand dyed in four shades of silver gray, and the irregular shapes and subtle tones were achieved by piecing the quilt from one-inch squares of the dyed fabric. Photograph: Mary Ellen Moscardelli. (Richard Johnson)

56 (below). *August Fog Dance*, Mary Ellen Moscardelli, 1975. 75″ x 75″. Velveteen and cotton. Direct dyed and quilted. Here the artist has achieved, through dyeing techniques, the soft, muted atmosphere of the late-summer fog. Photograph: Mary Ellen Moscardelli. (Richard Johnson)

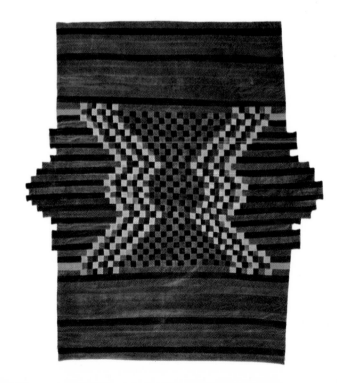

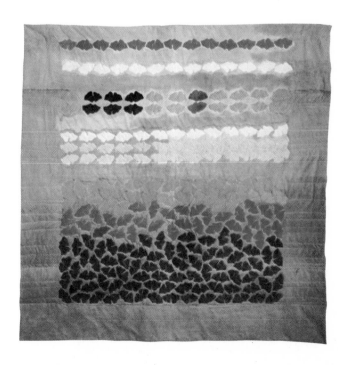

57 (below). *Colorado Sanitarium*, Cindy Miracle, 1977.
24″ x 16″. Cotton and textile pigments. Photo-silk-screened,
Xerox color transfer printed, and trapunto quilted.
In this piece, one of an *Interior Landscape* series, the
lunar landscape illusions are played against the rigid
confines of a sanitarium. Photograph: Cindy Miracle.
(Artist's collection)

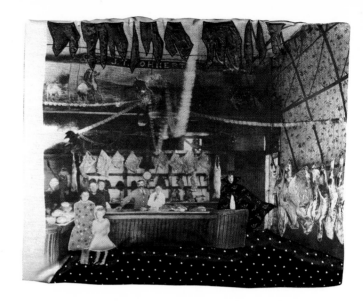

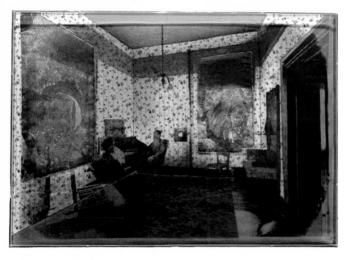

58 (above). *Butcher Shop*, Cindy Miracle, 1976. 20″ x 16″.
Cotton, rayon, and textile pigments. Photo-silk-screened,
appliquéd, and trapunto quilted. Another in the *Interior
Landscape* series, this piece involves the injection of
fantasy imagery to intentionally alter the mundane content
of the original photograph. Photograph: Cindy Miracle.
(Artist's collection)

59 (below). *Silver Bank*, Cindy Miracle, 1976. 24″ x 20″.
Satin and cotton. Photo-silk-screened with pigment,
appliquéd, and trapunto quilted. In this piece from the *In-
terior Landscape* series, the subtle manipulations through
printing and stitching have altered the innate perspective
of the photograph. Photograph: Cindy Miracle.
(Artist's collection)

60 (right.) *Renaissance*, Cindy Miracle, 1976. 66″ x 54″.
Acetate, rayon, satin, and textile pigments. Photo-silk-
screened, appliquéd, and trapunto quilted. In this piece the
artist was concerned with perspective and the illusion of
space. Alberti's formula for achieving an illusion of three
dimensions was applied to this design. Photograph: Cindy
Miracle. (Artist's collection)

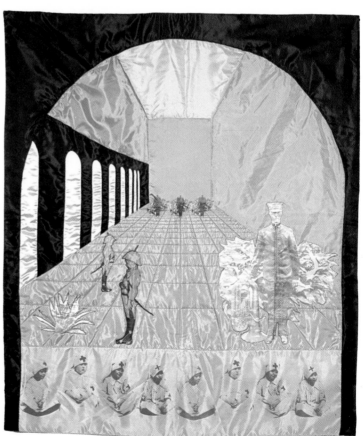

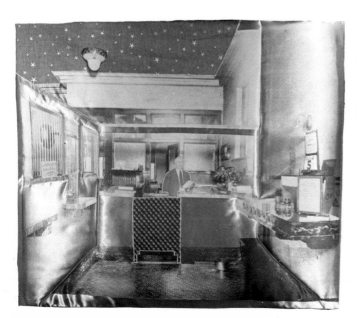

61 (opposite). *Crazy Quilt*, Meredith Lightbown, 1976.
75″ x 50″. Cottons and synthetics. Pieced, stitched, and
tufted. Impressed by the nature of the Swiss grid system of
design, the artist created this quilt to experiment with
fabric in that paradigm. Photograph: Mimi Dolbier.
(Artist's collection)

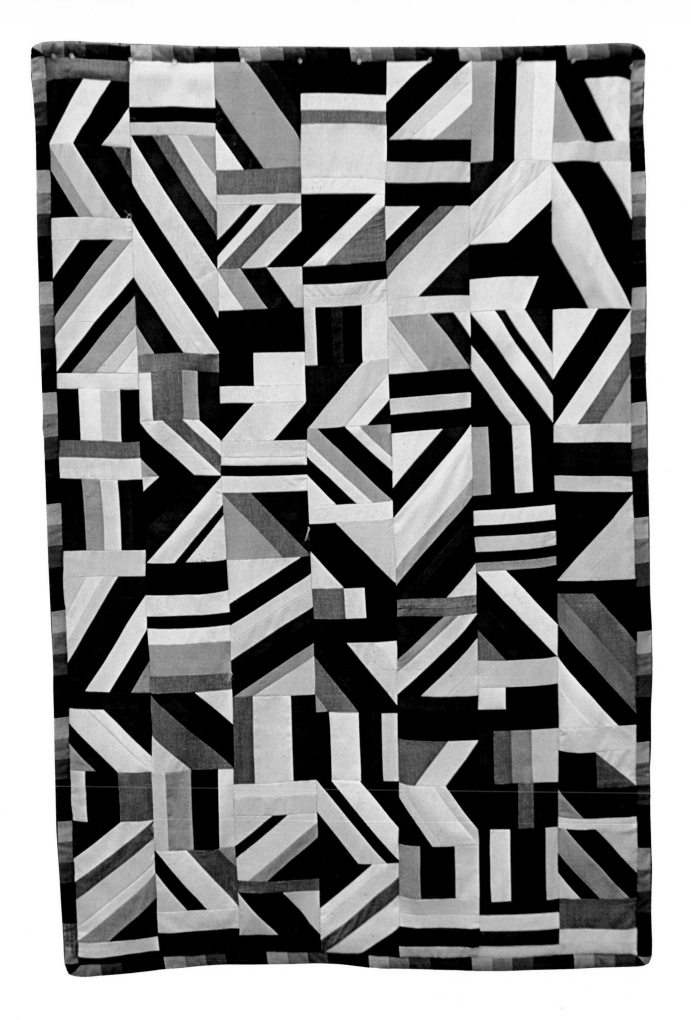

41

III. MYTHS, DREAM, AND VISIONS

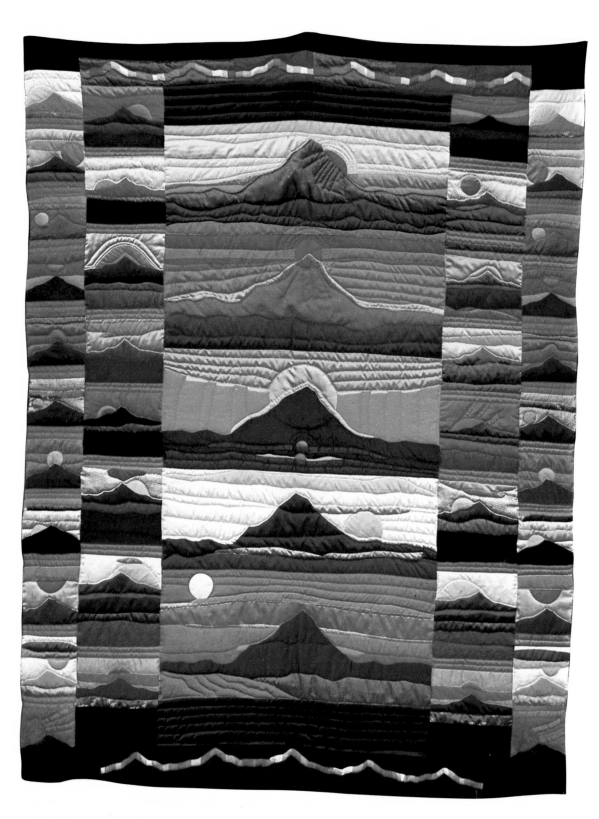

62 (above). *The Mountain in the Morning*, Helen Bitar, 1976. 106″ x 83″. Satins, cottons, corduroy, synthetics, silk, and wool. Appliquéd and quilted. A glorious tribute to a beloved mountain, this piece reflects the artist's truly inspired use of fabric to re-create a very personal landscape. Photograph: Helen Bitar. (Artist's collection)

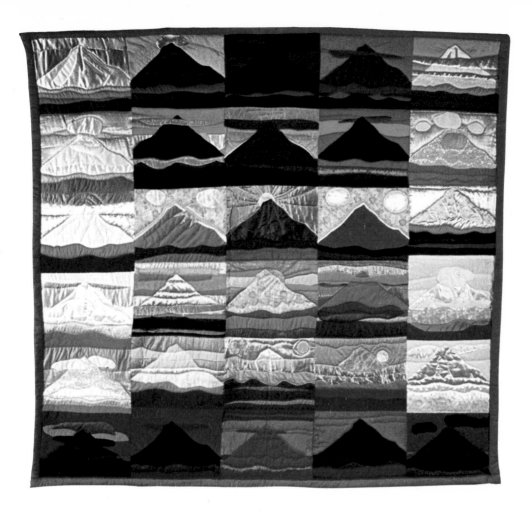

63 (above). *The Mountain from My Window,*
Helen Bitar, 1975. 100″ x 100″. Satins, cotton, silk,
and synthetics. Appliquéd and quilted. Here the
artist has dealt with a familiar and loved scene
in a way that reflects, through appliquéd image
and color placement, the peaceful nature of her
environment. Photograph: Little Bobby Hanson.
(Artist's collection)

64 (right). *Ribbon Quilt,* Helen Bitar, 1975.
63″ x 55″. Satins, velveteen, corduroy, cotton,
synthetics, and wools. Appliquéd, stitched, and
quilted. Inspired by the rich, dark hues of early
winter, the artist has created a colorful celebration
with her fantastically appliquéd ode, from
Goodwill remnants. Photograph: Helen Bitar.
(Private collection)

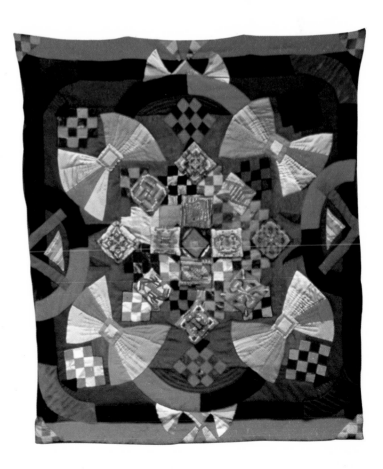

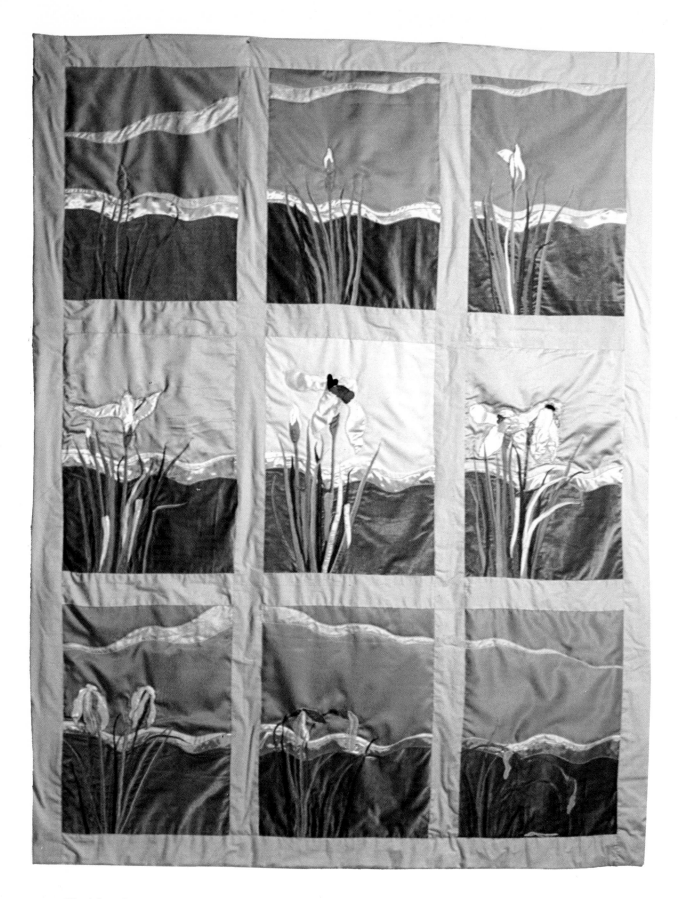

65 (above). *Iris Opening*, Sheila Perez, 1977. 82″ x 63″. Velveteen, satin, and cotton. Appliquéd and quilted. The sequential order of the blocks leads the observer to read this piece in the same manner as one would turn the pages of a book. Photograph: Sheila Perez. (Artist's collection)

66 (right). *Aerial Jungle Orchids,* Sheila Perez, 1977. 36″ x 27″. Cotton velveteen, with dye painting, and satin. Appliquéd and quilted. The silvery blue tones of this exotic hanging give it an otherworldly quality of floating suspended imagery. Photograph: Sheila Perez. (Artist's collection)

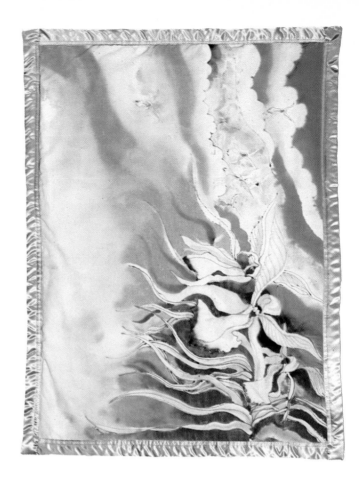

67 (below). *Nocturnal Garden,* Sheila Perez, 1977. 79″ x 68″. Velveteen, satin, and cotton. Dye painted, appliquéd, and quilted. In this piece the mysterious energies of the night transform the garden, making it a dreamlike place. Photograph: Peter Drost. (Artist's collection)

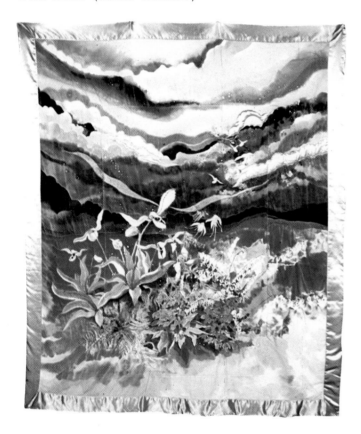

68 (right). *Night Quilt,* Sheila Perez, 1976. 82″ x 62″. Velveteen, satin, cotton, and lamé. Pieced, appliquéd, and trapunto quilted. The subtle visual effects of the passing of time are captured in this striking quilt. Photograph: Peter Drost. (Mrs. Ralph Glendinning)

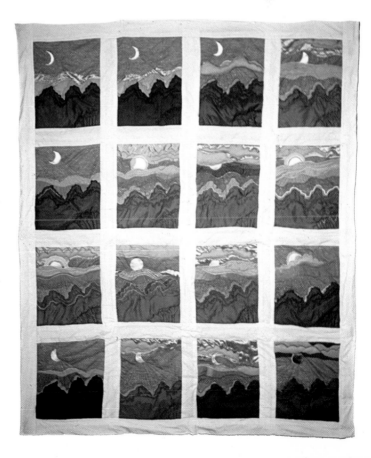

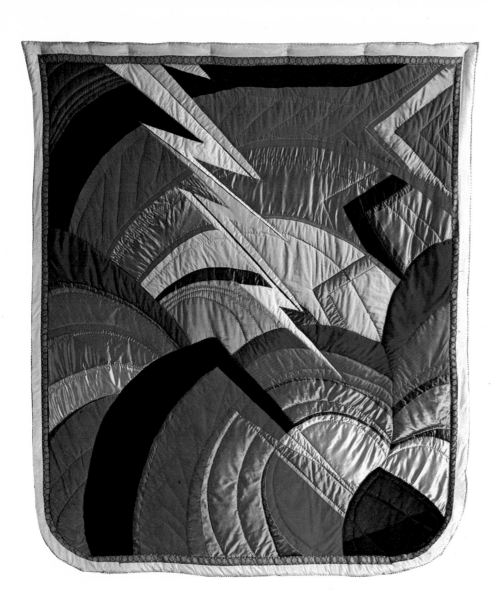

69 (left). *Lightning Bolt*, Leslie Fuller, 1977. 107″ x 96″. Satin, velvet, and watered silk. Appliquéd and quilted. The cool, elegant purples and blues of this piece, combined with the sharp, carefully worked design, give it exactly the impact the title suggests. Photograph: Robert Grossblatt. (Private collection)

70 (below, left). *Aerial View*, Leslie Fuller, 1977. 117″ x 103″. Satin, cotton, and corduroy from pants. Appliquéd and quilted. The enormous scale of this piece, which was designed from aerial photographs, makes it a fabric panorama. Photograph: Robert Grossblatt. (Artist's collection)

71 (below, right). *Laughing Dragon*, Leslie Fuller, 1975. 102″ x 88″. Satin, velvet, brocade, and polished cotton. Appliquéd, pieced, and trapunto quilted. This work is bordered by mandala gates and the dragon interacts with the mandalas for a strong visual impact. Photograph: Robert Grossblatt. (Wesley E. Craven)

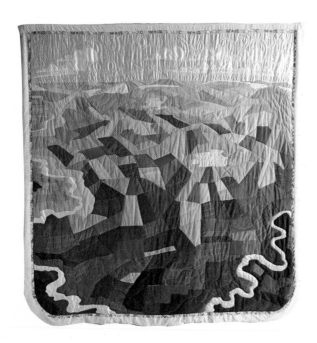

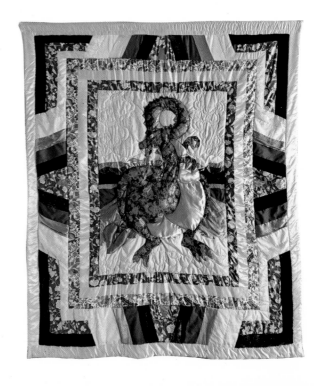

72 (right). *Seeing*, Sas Colby, 1976. 78″ x 60″. Silk and cotton. Pieced, appliquéd, Xerox photo-transferred, and quilted. Transformations from chaos to calm, through new insights (the eye and the cloud) and new strength (the rainbow), make this a very contemplative piece. Photograph: Sas Colby. (Private collection)

73 (below, left). *Rainbow Quilt*, Sas Colby, 1975. 60″ x 60″. Silk and taffeta. Pieced and quilted. This work, designed and pieced by the artist and quilted by Andrea Mildenberger, takes a traditional geometrical idea and gives it motion and a kaleidoscopic effect through the choice of fabrics and colors. Photograph: Mimi Dolbier. (Artist's collection)

74 (below, right). *Phoenixville*, Sharon R. Myers, 1977. 96″ x 96″. Cotton chintz. Pieced, appliquéd, stuffed, and quilted. The stark image of the tree silhouetted against the black sky is softened by the use of bright printed fabric. Photograph: William McCloy. (Artist's collection)

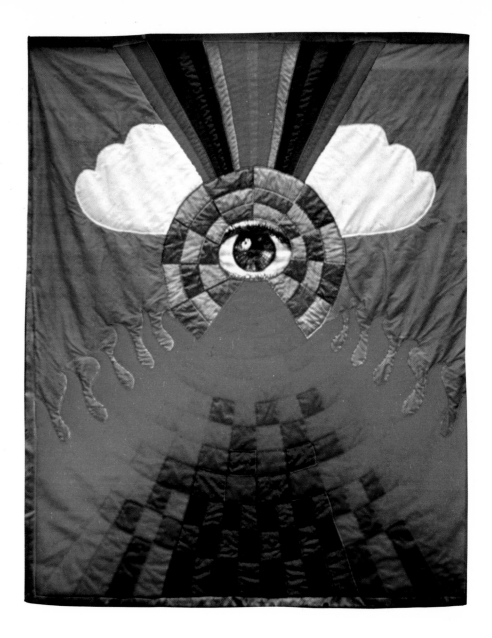

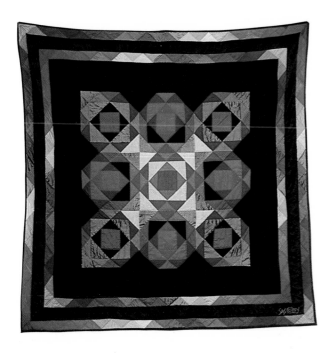

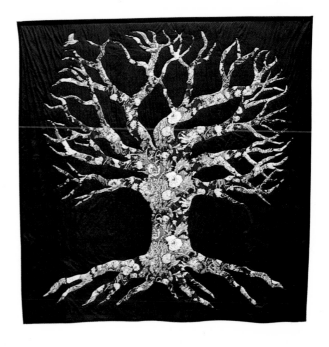

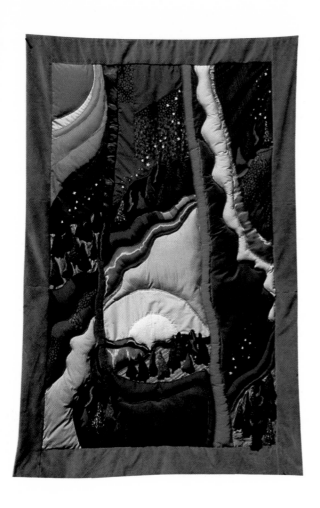

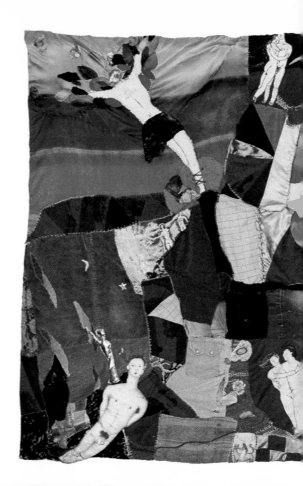

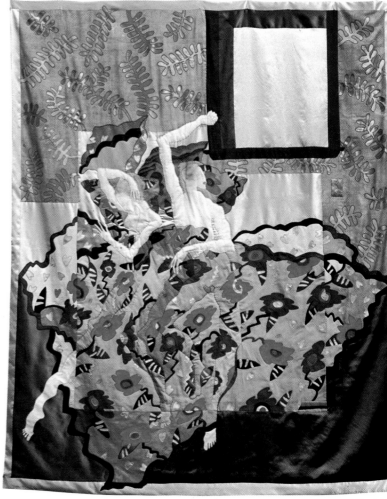

75 (above). *North Woods Dream*, Joan A. Peters, 1976. 66″ x 42″. Velvet, satin, corduroy, hand-dyed cotton, and sequins. Pieced, appliquéd, and trapunto quilted. The interplay of the bright colors with the forms in this piece gives it a magical quality. Photograph: Douglas Frantz. (Artist's collection)

76 (right.) *Valentine Quilt*, Risë Nagin, 1977. 80″ x 66″. Cotton, acetate, satin, linen, silk, and acrylic paint. Pieced, appliquéd, quilted, embroidered, and painted. Cleverly including a quilt within a quilt, the artist has taken care to conceal and at the same time reveal the sleeping figures. Photograph: Risë Nagin. (Private collection)

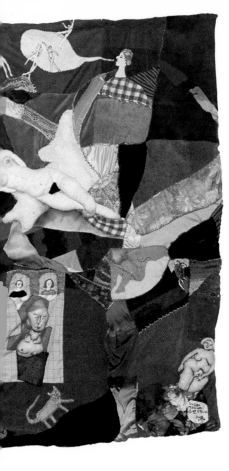

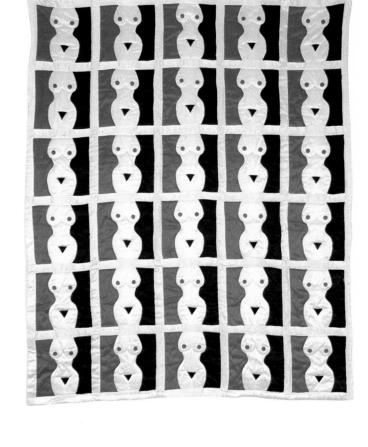

77 (above, center). Untitled, Susan Gofstein, 1976. 48″ x 60″. Felt, cotton, velvet, wool, nylon, silver lamé, and satin. Pieced, stuffed, appliquéd, trapunto quilted, embroidered, and hand painted. The playful, erotic imagery and a sense of comic proportion give this piece the flavor of a pop cartoon. Photograph: Mimi Dolbier. (Artist's collection)

78 (above, right). *American Beauty with Pocket,* Wendy Ross, 1975. 80″ x 90″. Satin acetate. Appliquéd and quilted. The artist takes a good-natured poke at displaced aesthetic priorities with this humorous "propaganda." Photograph: Tim Donahue. (Private collection)

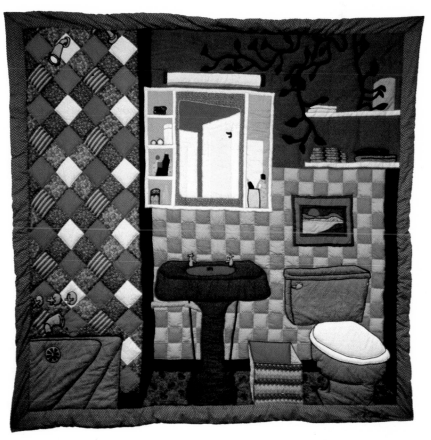

79 (right). *Bathroom Quilt,* Rebecca Scott Lackman, 1977. 94″ x 86″. Cotton and remnants. Pierced, appliquéd, and quilted. Here the artist immortalizes the sacred, family bathroom with a faithful rendition in fabric. Photograph: William D. McClatchie, Foster-Bush. (Artist's collection)

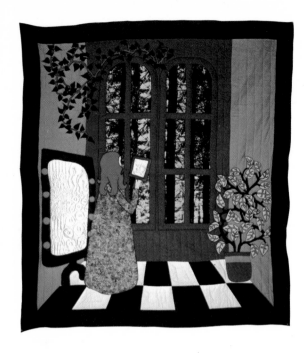

80 (left). *Figure/Mirror Quilt,* Rebecca Scott Lackman, 1977. 94″ x 86″. Cottons and synthetics. Pieced, appliquéd, and quilted. The use of perspectives and angles and the execution of the central figure in rich fabrics and tones lend this quilt a charming narrative quality. Photograph: William D. McClatchie, Foster-Bush. (Artist's collection)

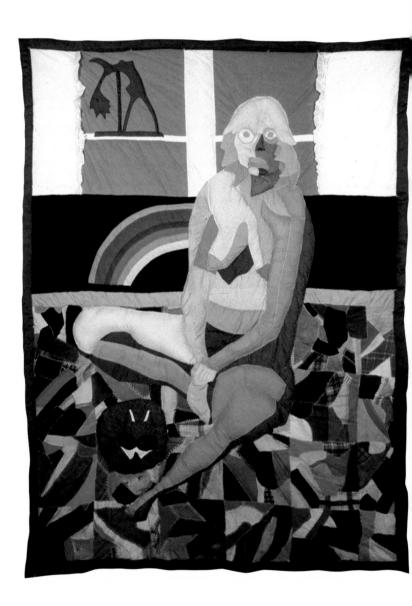

81 (below). *Susan and Little Bear,* Nancy Wright, 1975. 93″ x 85″. Cotton. Appliquéd, stuffed, and quilted. This quilt depicts two friends who made wonderful sleeping companions in cold climates! Photograph: Peggy McMahon. (Susan Goodman)

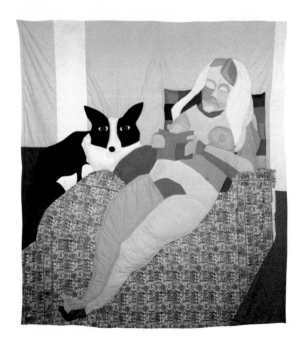

82 (above). *Self-Portrait,* Nancy Wright, 1977. 85″ x 74″. Cotton, Appliquéd, stuffed, and quilted. A simple self-portrait with a sleeping friend becomes vibrant by the addition of an elaborate old crazy quilt remnant to the peaceful scene. Photograph: Peggy McMahon. (Artist's collection)

83 (above). *Table and Spider Plant,* Cynthia Nixon, 1976. 36″ x 24″. Satin and muslin. Pieced, appliquéd, and quilted, with stuffed projections.. The stuffed satin leaves of the spider plant protrude invitingly from the quilt, producing a delightful tactile, as well as visual, image. Photograph: Cynthia Nixon. (Private collection)

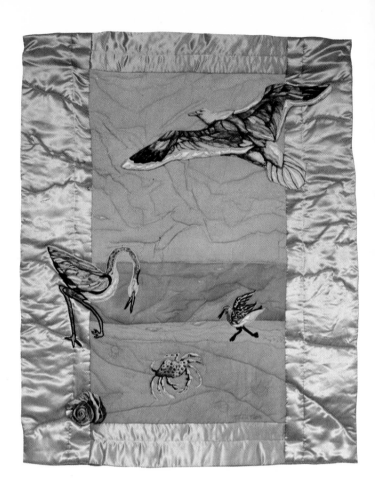

84 (below). *Goose Rocks Mona Lisa*, Cynthia Nixon, 1976. 24″ x 16″. Muslin, satin, and acrylic paint. Pieced, appliquéd, quilted, trapunto stuffed, painted, and embroidered. The whimsical nature of the piece is due in part to the creation of the figure as a separate pieced, stuffed, and painted unit, which is loosely attached to the body of this fabric work. Photograph: Dan Brody. (Artist's collection)

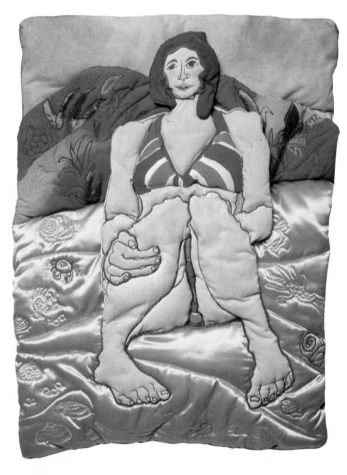

85 (above, right). *Goose Rocks Revisited*, Cynthia Nixon, 1976. 56″ x 48″. Ink, muslin, satin, and acrylic paint. Drawn, pieced, appliquéd, and quilted, with stuffed projections. In this very personal geography, seabirds and a clam are detailed in pen and ink on muslin, and the sea gull is a separate, stuffed, sculptural element. Photograph: Dan Brody. (Artist's collection)

86 (right). *Holy Family*, Cynthia Nixon, 1976. 30″ x 40″. Muslin, satin, acrylic paint, and ink. Drawn, appliquéd, pieced, quilted, and embroidered. This richly symbolic depiction of a strong mother figure with children gives a very realistic view of the spiritual and biological bonds between a woman and the world. Photograph: Dan Brody. (Private collection)

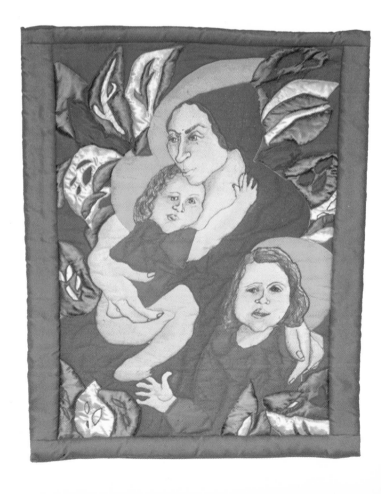

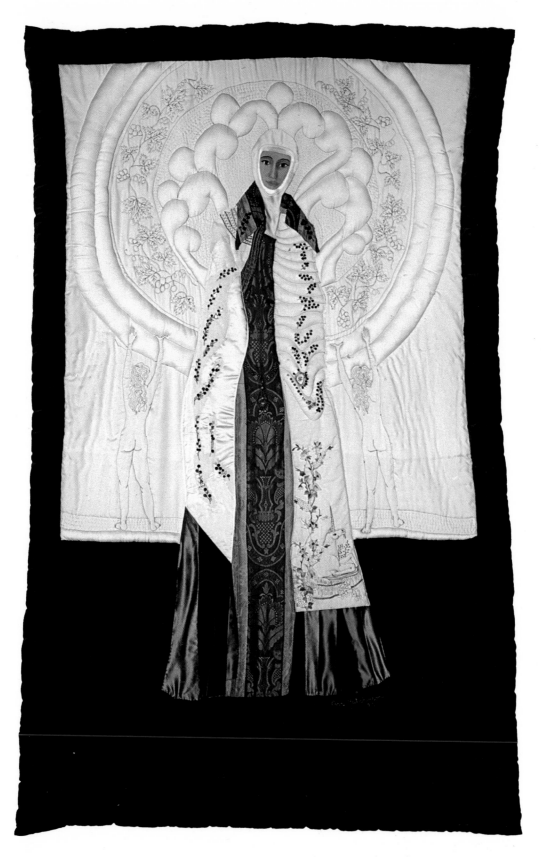

87 (above). *Large Madonna,* Ann Hutchinson, 1977. 78″ x 54″. Velvet, antique curtains, cottons, satins, silk, synthetics, and sequins. Freehand machine embroidered, trapunto quilted, appliquéd, painted, and beaded. The artist used her sewing machine as a tool for the line drawing of the grapevines, the figures, and the unicorn. Photograph: Steve Winkler. (Artist's collection)

88 (right). Untitled landscape, Ann Hutchinson, 1977. 48″ x 42″. Velvet, silk, synthetics, and embroidery floss. Freehand machine embroidered, quilted, and appliquéd. Subtle colorations, and the contrast of lighter and darker images, are the artist's focus for what becomes a sewed line drawing. Photograph: Steve Winkler. (Artist's collection)

89 (below). *Jacona Plaza,* Ann Hutchinson, 1977. 48″ x 42″. Velvets, cottons, synthetics, silks, chiffon, and wool. Pieced, appliquéd, stuffed, and freehand machine embroidered. The extraordinary detail of a literal scene and the subtle colorations and shadings of the New Mexico landscape show the artist's deep understanding and appreciation of her environment. Photograph: Steve Winkler. (Artist's collection)

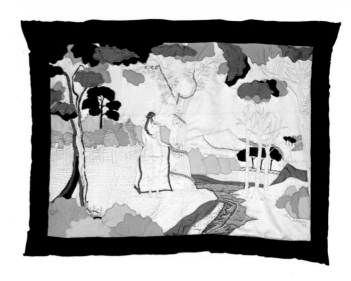

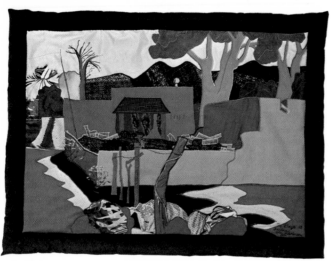

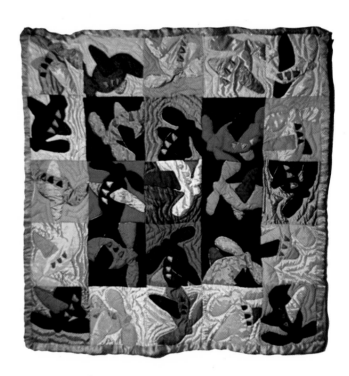

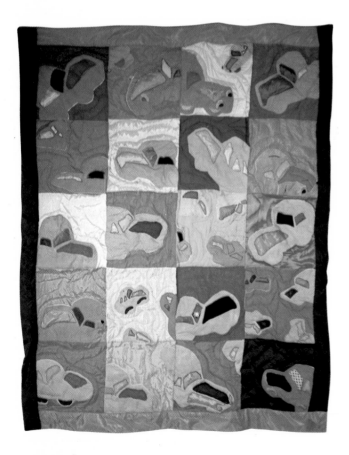

91 (above). *Airplane II,* Karen Katz, 1975. 72″ x 60″. Satin. Appliquéd and quilted. With their comic-book personas, these floppy, personable airplanes appeal to the imaginations of children and adults alike. Photograph: Karen Katz. (Artist's collection)

90 (left). *Car Quilt,* Karen Katz, 1974. 72″ x 60″. Satin, taffeta, and assorted fabrics. Quilted, appliquéd, and pieced. This was made for a child and achieves a wonderful humorous quality in the droll rendering of fantasy cars. Photograph: Karen Katz. (Artist's collection)

92 (right). *Who's That Dreaming in My Bed?*, Karen Bradford, 1977. 88″ x 88″. Satin, velvet, cotton, and fur. Appliquéd and quilted. An evocation of the powers of the dreamer and the dreamed, this quilt includes Technicolor dreams of cats as well as of lovers. Photograph: Robert Grossblatt. (Artist's collection)

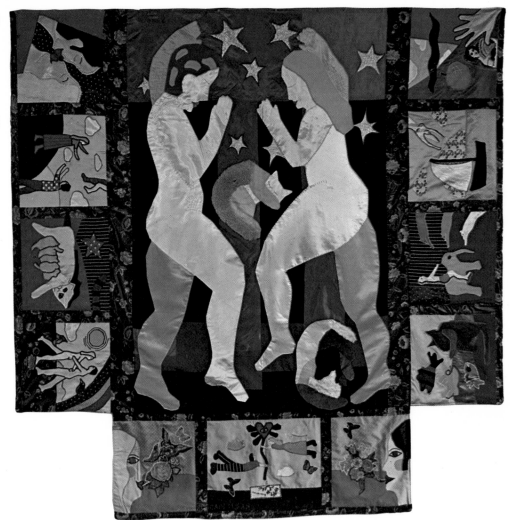

93 (below, left). *Dream of Africa I*, Carol Beckwith, 1976. 39″ x 64″. Swahili men's skirts, West African dyed and woven fabrics, Akindra cloth, Cenci fabrics, English scarves and blouse material. Appliquéd and embroidered. In this first of a series, the focus is on the sleeping figure surrounded by lush vegetation and surrealistic creatures (of the imagination). Photograph: Peggy McMahon. (Artist's collection)

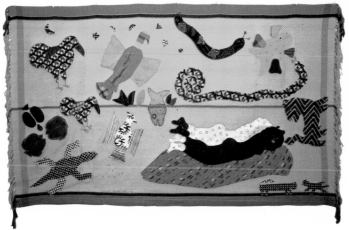

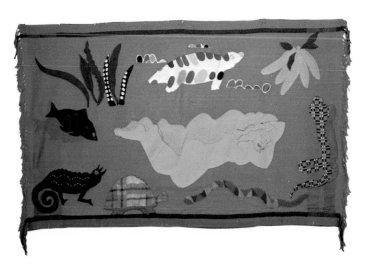

94 (above). *Dream of Africa II*, Carol Beckwith, 1976. 39″ x 62″. Swahili men's skirts, West African dyed and woven fabrics, Akindra cloth, Cenci fabrics, English scarf and blouse material, Swahili friend's hair. Appliquéd and embroidered. In this hanging, the artist dreams of assuming the identity of an African friend. The second figure then becomes a shadow. Photograph: Peggy McMahon. (Artist's collection)

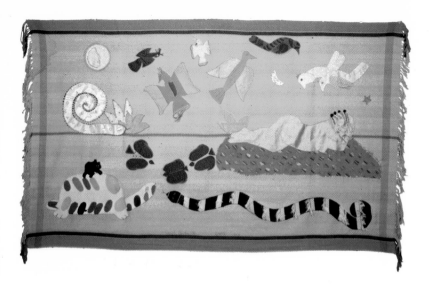

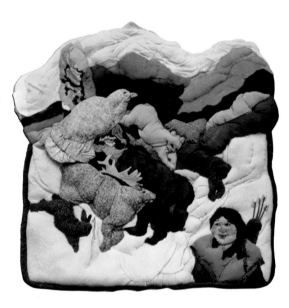

97 (below). *The Fisher Who Let Out Summer*, Jean Carlson, 1974. 22″ x 24″. Cotton, wool, satin, and felt. Hand dyed, pieced, and stuffed. The artist exhibits great control in her fabric illustration, using hand-dyed colors for specific natural effects, and stuffing her characters for a lifelike quality. Photograph: Jean Carlson. (Artist's collection)

95 (above). *Dream of Africa III*, Carol Beckwith, 1976. 39″ x 64″. Swahili men's skirt, West African hand-dyed and woven fabrics, Akindra cloth, Cenci fabrics, English scarves and blouses, Swahili friend's hair. Appliquéd and embroidered. In this last of the series, the artist focused on developing in cloth the fantastic animals that inhabit her dreams of Kenya. Photograph: Peggy McMahon. (Artist's collection)

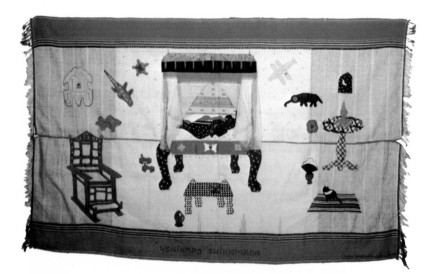

98 (below). *The Spring Maiden and the Winter Man*, Jean Carlson, 1974. 22″ x 24″. Cotton, crochet yarn, sheep fleece. Hand dyed, pieced, embroidered, crocheted, appliquéd, and stuffed. Here the artist has symbolically represented the changing seasons by portraying spring as a young woman and winter as an old man. Photograph: Jean Carlson. (Artist's collection)

96 (above). *Ushikapo Shikamana*, Carol Beckwith, 1977. 42″ x 70″. Swahili men's skirts, West African hand-dyed and woven fabrics, Indian bells and fabrics. Appliquéd, thread caned, embroidered. The ancient Swahili proverb *Ushikapo Shikamana* is a form of advice given to newlyweds and is translated: "When you hold it, hold it tight." Photograph: Peggy McMahon. (Artist's collection)

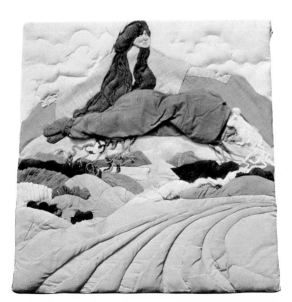

99 (left). *Starshine*, Paula Jo Meyers, 1976. 90″ x 96″. Cotton denim. Pieced, quilted, and appliquéd. The artist's use of scraps from naturally faded jeans achieves the soft blue tone of this quilt and is an interesting way to develop something really special from the mundane. Photograph: Mimi Dolbier. (Anita Ruthling Klaussen Collection)

100 (below, left). *Romany Jungle*, Lee Farrington, 1977. 65″ x 95″. Satin and cotton. Pieced, appliquéd, and quilted. Here the artist captures the mood of a sultry summer night. The image of the sleeping city and the barely visible figures in the foreground are strong visual elements in this intricately pieced quilt. Photograph: Peggy McMahon. (Artist's collection)

101 (below, right). *Winterlight,* Lee Farrington, 1976. 65″ x 75″. Velvet, velour, satin, and cotton. Appliquéd, pieced, and quilted. An investigation into myth, symbol, and spirit, through the use of strong visual images, makes this quilt both bizarre and exotic. Photograph: Peggy McMahon. (Artist's collection)

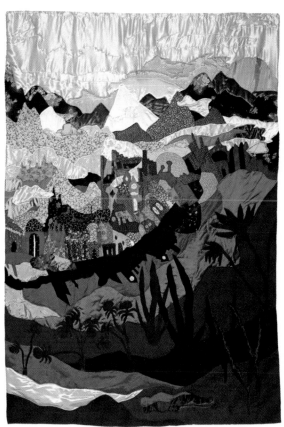

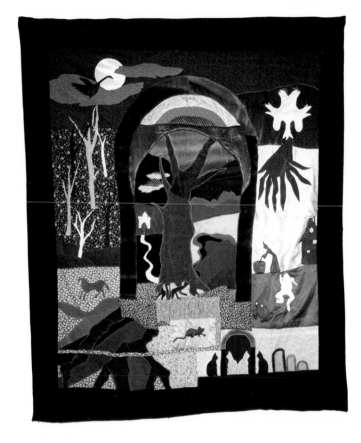

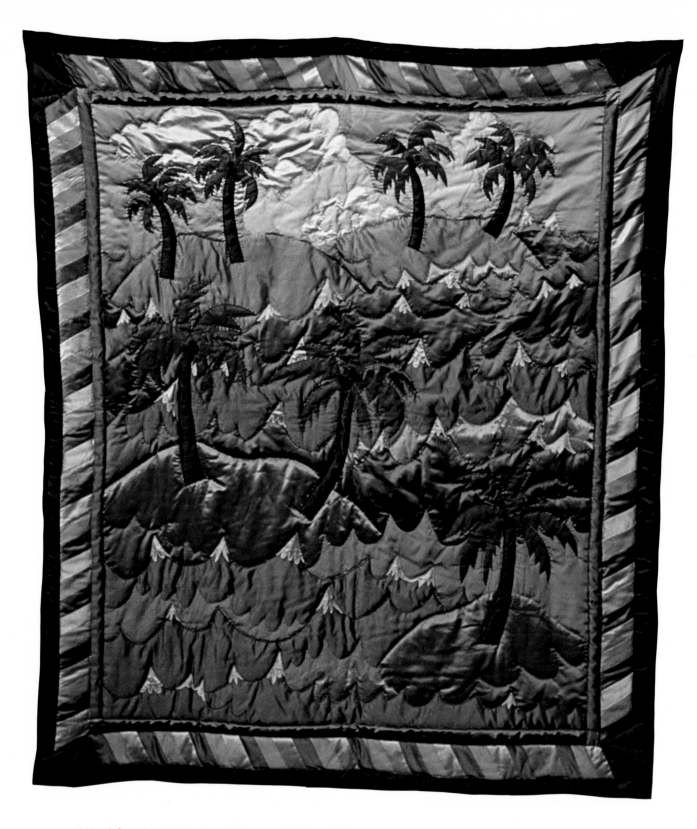

102 (above). Untitled quilt, Susan Fulmer, 1976. 77″ x 86″. Satin and cotton. Appliquéd, pieced, and quilted. With a storm at sea, wind-tossed palm trees, and rough-and-tumble whitecaps, the artist has imbued this piece with an enormous amount of movement and rhythm. Photograph: Carolyn Sparling. (Private collection)

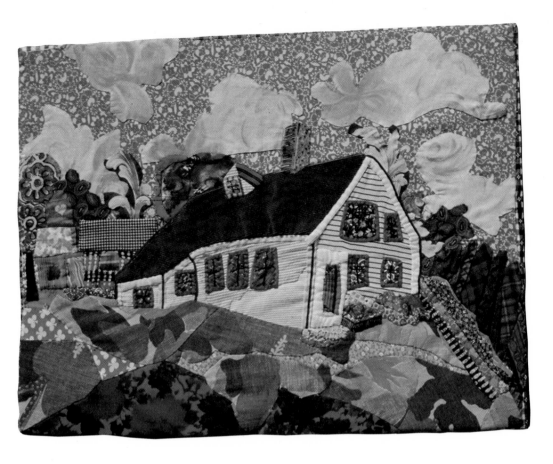

103 (left). *Couchtown Road House,* Betsy Grob Giberson, 1975. 30″ x 25″. Cotton rummage. Appliquéd and quilted. Intended as a colorful portrait of a familiar landmark, the homey image here has a very contemporary folk flavor. Photograph: Betsy Grob Giberson. (Artist's collection)

104 (right). *Pillsbury Free Library,* Betsy Grob Giberson, 1975. 28″ x 25″. Cotton rummage. Appliquéd and quilted. Here form and image merge in the artist's drawing of a rather detailed portrait of a building in intensely bright, printed fabrics. Photograph: Betsy Grob Giberson. (Norman Stevens Collection)

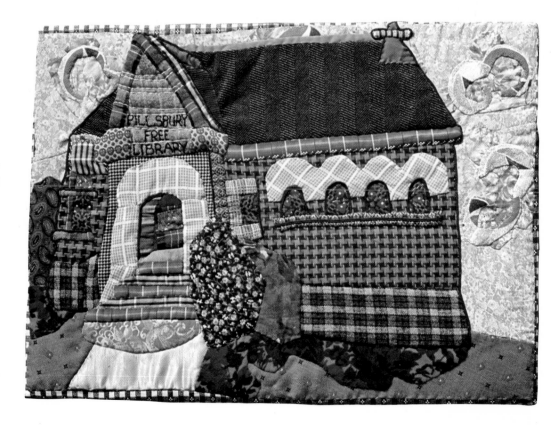

IV. MULTIDIMENSIONAL QUILTS AND FABRIC ART

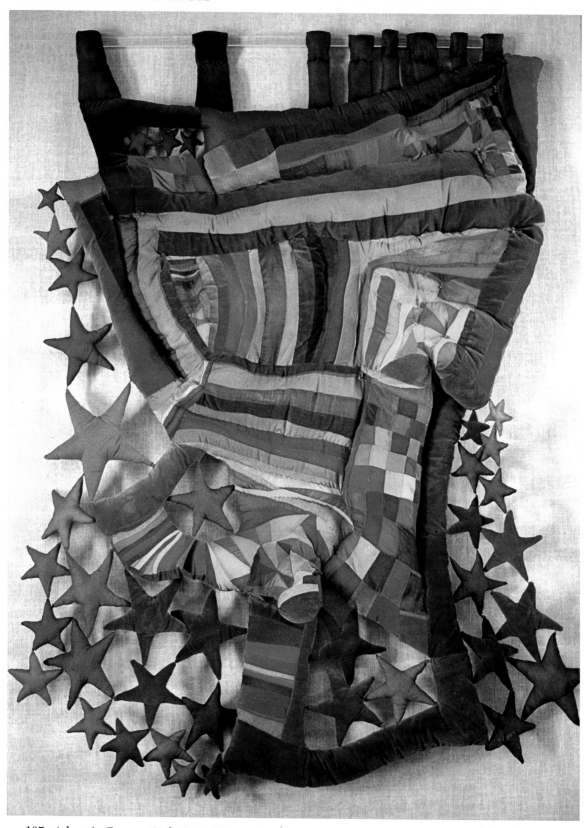

105 (above). *Bumpy Quilt,* Jody Klein, 1973. 45″ x 60″. Cotton velveteen and cotton. Hand dyed, pieced, stuffed, and quilted. This quilt was put together from scraps from other hand-dyed pieces, which were sorted into shapes as they occurred and stuffed for a multidimensional effect. Photograph: Jody Klein. (Artist's collection)

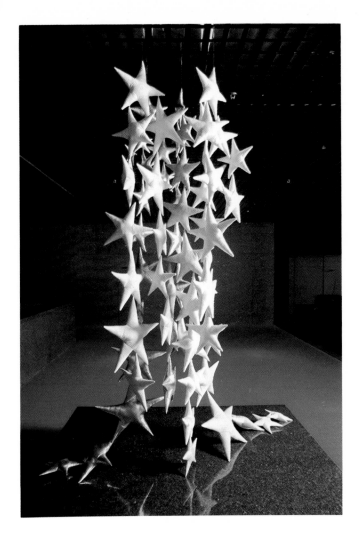

106 (left). *Star Galaxy,* Jody Klein, 1974. 120″ x 36″ x 36″. Cotton-and-Dacron canvas, silver metallic fabric, gray cotton moiré stars, polyester stuffing. Stitched and stuffed. Each star was individually fabricated from silver cloth, then joined to the others to make a large hanging unit. Photograph: Roger Phillips. (Ohio Building Authority)

107 (below, left). *Heart-Shaped Box for Stuffed Stars,* Jody Klein, 1973. 24″ x 24″ x 9″ (closed). Cotton, cotton velvet, embroidered textiles, and polyester stuffing. Pieced, quilted, beaded, stitched, and stuffed. As well as being gloriously decorated with beadwork, embroidery, and appliqué, the whole box is generously padded to make a soft container for the stars. Photograph: Mimi Dolbier. (Artist's collection)

108 (below, right). *186 Cascading Hearts, Some with Stars Attached,* Jody Klein, 1972. 109″ x 36″ x 6″. Procion-dyed cotton and cotton velvet, and polyester stuffing. Stitched and stuffed. The assemblage technique is demonstrated in this piece, where a sculptured piecework concept employs many small units composing a large one. The heart shape is a favorite theme of the artist. Photograph: Jody Klein. (Artist's collection)

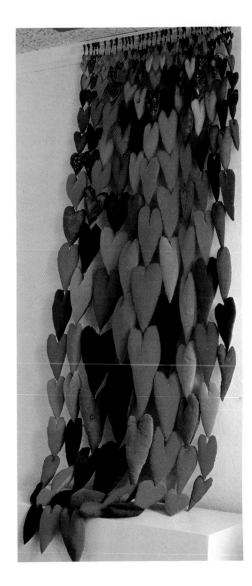

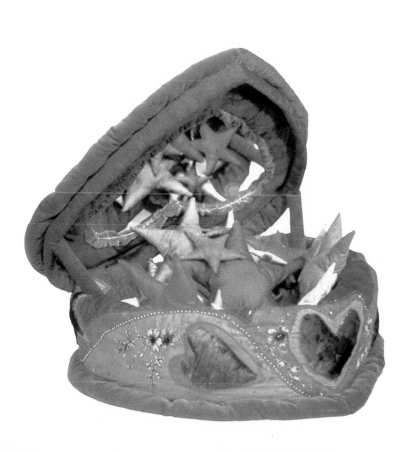

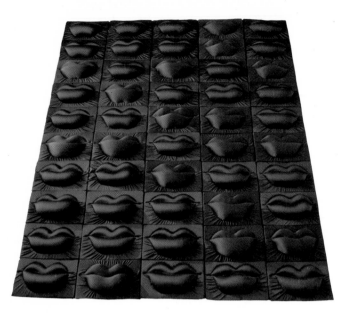

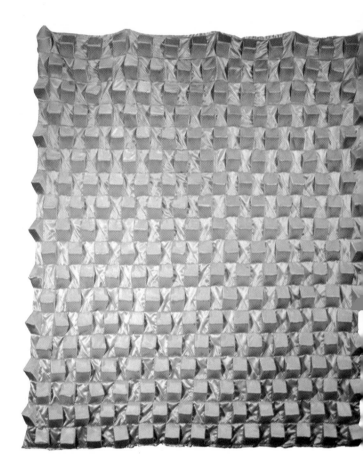

109 (above). *Landscape in Blue* (front), Gwen-lin Goo,
1973. 72″ x 84″ x 4″. Cast polyurethane foam and Quiana.
Cast and hand stitched with pliers. By combining inorganic
materials and forms that are usually associated with
sculpture with the fluidity of Quiana fabric, the artist has
realized a dual intention. Photograph: Gwen-lin Goo.
(Artist's collection)

109a (below). *Landscape in Blue* (back), Gwen-lin Goo.
As is evident, this piece is intended to be viewed from both
sides. Photograph: Gwen-lin Goo.

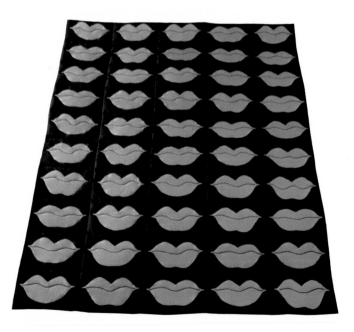

110 (above). *Pyramid Quilt*, Diane Castellan, 1976.
72″ x 72″. Satin, cotton, Procion dyes, polyester fiberfill, and
foam rubber. Pieced, stuffed, silk-screened, and quilted.
The three-dimensional effect of the silk-screened geometric
pattern on the back of the quilt is reflected on the front
in a three-dimensional relief, using the properties of the
satin to create deeper space. Photograph: Lawrence
Coleman, Jr. (Artist's collection)

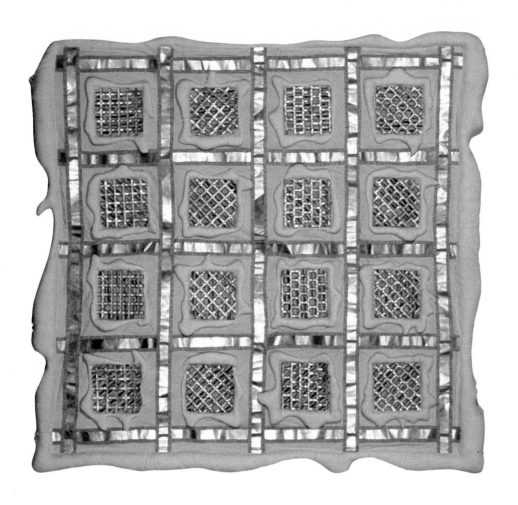

111 (above). *Aluminum Quilt,* Sandra Humberson, 1972. 50″ x 50″. Cotton, cotton blends, aluminum, and newsprint. Stitched and stuffed. The artist has employed the use of opposed media; the usual quilt fabric is combined with a very unusual material, aluminum, to create an interesting image. Photograph: Sandra Humberson. (Artist's collection)

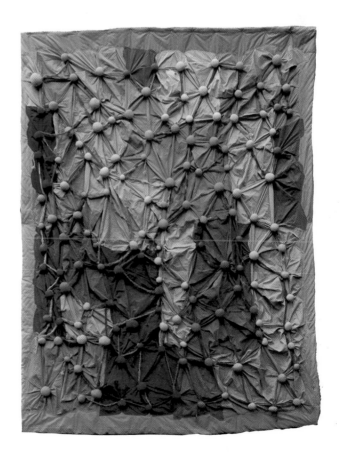

112 (right). Untitled quilt, Karen M. Lukas, 1975. 68″ x 85″. Dyed muslin, cotton cord, fiberfill. Dyed, tied, and gathered. In a reversal of a traditional African technique called *eleso,* the fabric was first dyed by the artist and then tied and gathered to create powerful surface tensions. Photograph: Mimi Dolbier. (Artist's collection)

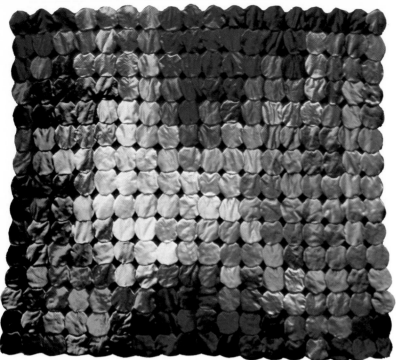

113 (left). *Metamorphosis*, Karen M. Lukas, 1975. 41″ x 52″. Satin. Stitched and assembled. Employing the "yo-yo" quilt assembling technique, the artist created a surface concerned with rich color interactions in a logical color progression. Photograph: Mimi Dolbier. (Artist's collection)

114 (below). *Recycled Goddess*, Ann Gati, 1977. 27″ x 44″. Fake fur, satin, and silver acetate. Machine quilted and appliquéd. The theme of this quilt resulted from the artist's contemplation of the archetypal, dark-side-of-the-moon symbol of the unconscious. Photograph: Lee Bowden. (Artist's collection)

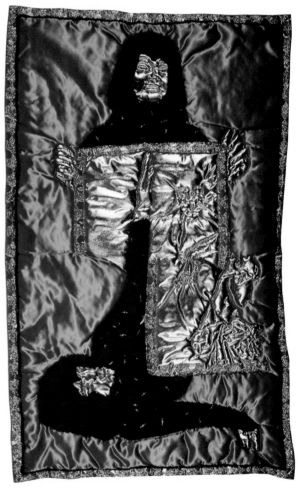

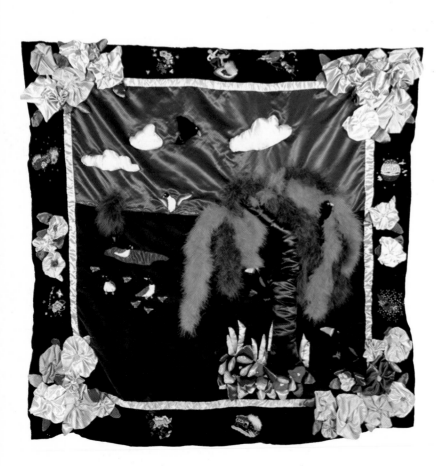

115 (left). *Bird and Flower Quilt*, Linda Abrams, 1977. 50″ x 48″. Satin, velvet, fur, rhinestones, feathers, and embroidery thread. Appliquéd, embroidered, and stuffed. Using a variety of materials, textures, and lush colors, the artist has created a fantastic jungle landscape. Photograph: Clark Quin. (Artist's collection)

116 (right). *Flower Quilt,* Nancy Britton, 1976. 72″ x 86″. Cotton velveteens and satin. Pieced, stuffed, and quilted. Rich texture and color and a departture from the usual rectangular quilt shape combine to make this piece striking. Photograph: Mimi Dolbier. (Mr. and Mrs. C. P. Cantine)

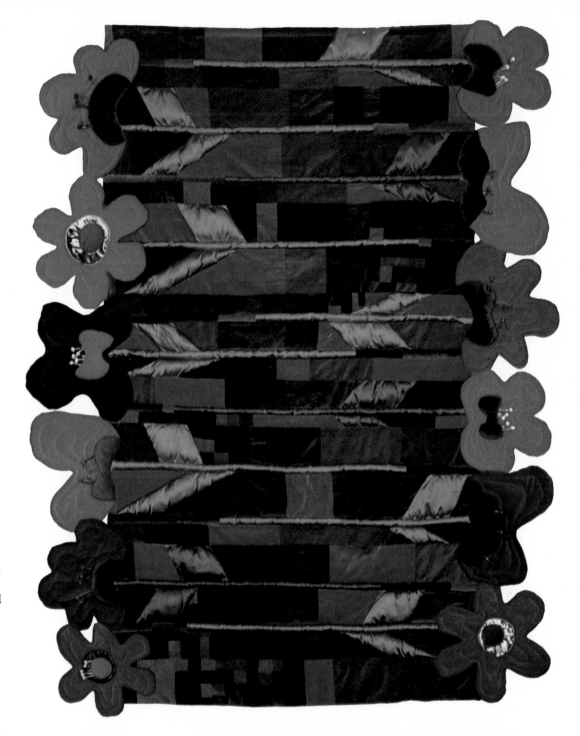

117 (below). *Stuffed Piece,* Tana Krizova Lizon, 1977. 72″ x 30″. Linen and corduroy. Quilted, appliquéd, and spray-painted. The geometrical design with soft, sprayed and stuffed areas composes an environment for the shapes within. Photograph: Peter Lizon. (Artist's collection)

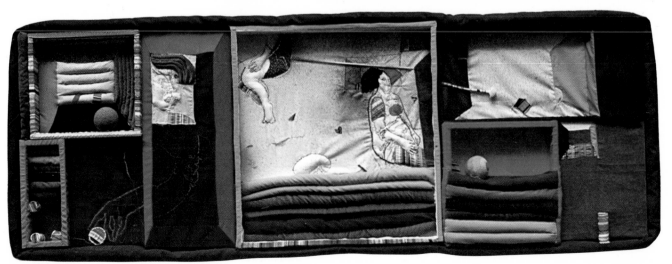

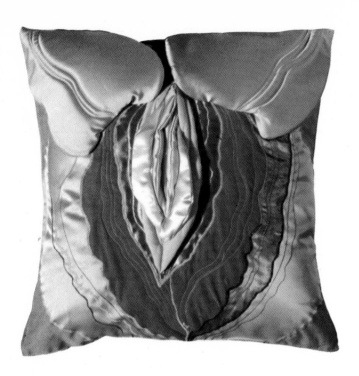

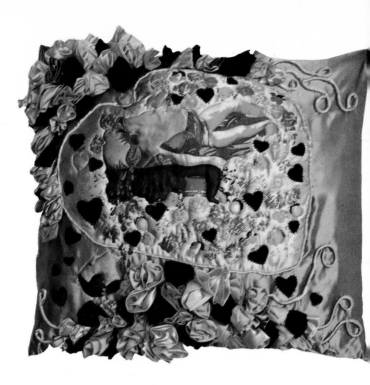

118 (above). *Iris,* Sheila Perez, 1977. 16″ x 16″. Cotton, satin, and velveteen. Stuffed, stitched, appliquéd, and quilted. The sensuous nature of this piece results in a very personal statement which needs no elaboration. Photograph: Sheila Perez. (Private collection)

119 (above). *Dreadful Sorry, Valentine,* Jan Moseman, 1974. 26″ x 24″ x 10″. Satin, taffeta, embroidery floss, cotton cording, batting. Photo-silk-screened, quilted, appliquéd, and embroidered. This pillow evokes a gruesome undercurrent, in a baroque context of lush satin flowers, printed and quilted roses, and embroidered hearts. Photograph: Jan Moseman. (Artist's collection)

120 (below). *Cloak for a Journey to the Heart of the Sun,* Pattie Chase, 1976. 90″ x 65″. Velvet and velveteen. Pieced, appliquéd, stuffed, and quilted. The deliberate composition of this piece gives it a startling stained-glass window effect. Photograph: Russell Windman. (Artist's collection)

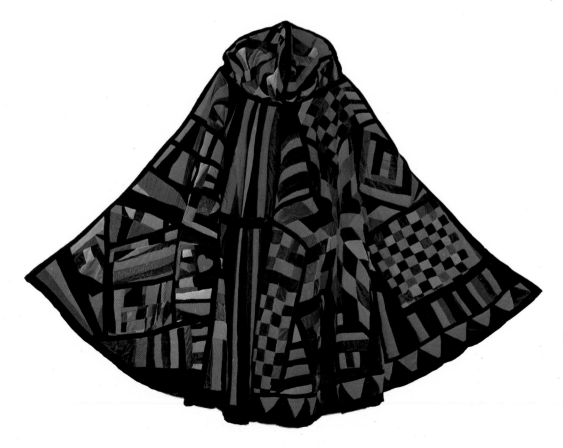

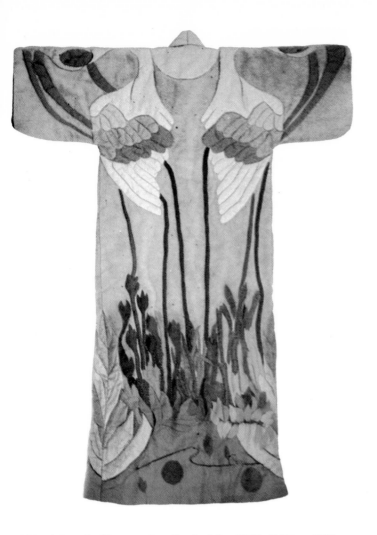

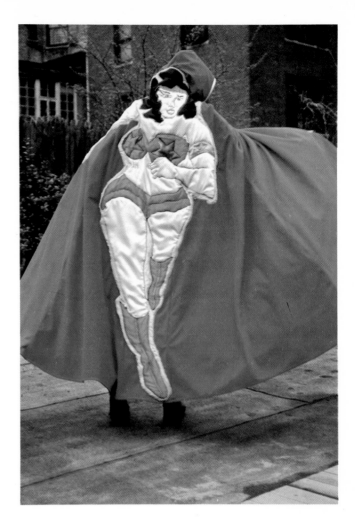

121 (above). *Kimono*, Joy Stocksdale, 1977. 54½″ x 41½″.
Sheer fabric, felt, silk buttonhole twist, and batting. Stitched
and quilted. The technique used in this piece was shadow
quilting. A sheer fabric covers the felt and batting,
a backing goes underneath, and the layers are then quilted.
Photograph: Joy Stocksdale. (Artist's collection)

122 (above). *Superwoman Cape*, Karen Katz, 1975.
100″ x 48″. Velour, satin, and batting. Appliquéd and
quilted. An original and exuberant characterization of a
popular fantasy figure, this piece is clearly meant for
movement. Photograph: Kathleen Benveniste.
(Private collection)

123 (right). *Catocala Moth*,
Suzanne Derrer, 1977. 120″ x 53″
x 9″. Velvet, satin, fur, crepe,
wool, and stuffing. Appliquéd,
quilted, and trapunto quilted.
True to nature, the wings can be
either in their disguised position
(closed) or open in a magnificent
display. Photograph: Suzanne
Derrer. (Artist's collection)

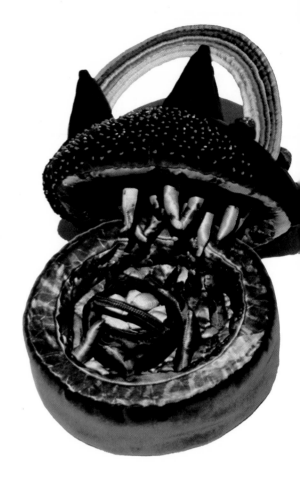

124 (above). *Blue Butterfly,* Suzanne Derrer, 1975. 110″ x 60″ x 3″.
Velvet, crepe, and stuffing. Appliquéd and quilted. Here, as in
her other pieces, the artist's keen observation of nature plays a
large part in the development of her overall design. Photograph:
Suzanne Derrer. (Michael Kahn)

125 (right). *Rainbow Hill,* Barbara Comstock, 1974. 8″ diameter.
Cotton velvet, suede cloth, silk/rayon satin, silk buttonhole twist,
polyester fiberfill, and polyurethane foam. Appliquéd, embroidered,
quilted, and tie-dyed. This three-dimensional construction evokes
a miniature fantasy landscape and is one of a group of pieces that
open to reveal the inner workings of the earth. Photograph:
Craig Comstock. (Artist's collection)

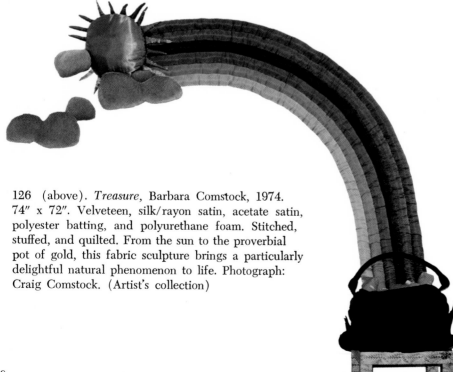

126 (above). *Treasure,* Barbara Comstock, 1974.
74″ x 72″. Velveteen, silk/rayon satin, acetate satin,
polyester batting, and polyurethane foam. Stitched,
stuffed, and quilted. From the sun to the proverbial
pot of gold, this fabric sculpture brings a particularly
delightful natural phenomenon to life. Photograph:
Craig Comstock. (Artist's collection)

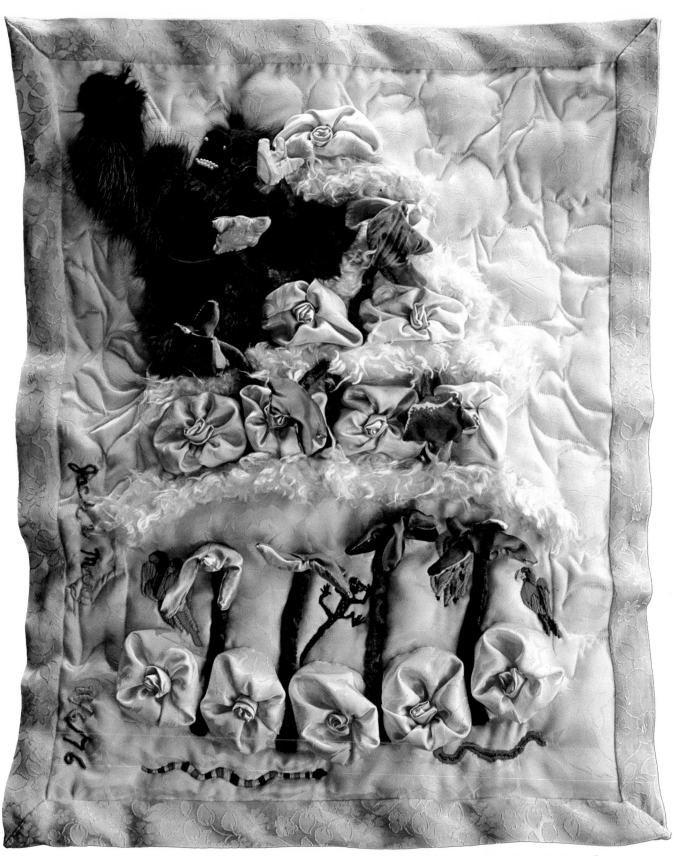

127 (above). *King Kong Climbing a Wedding Cake*, Agusta Agustsson, 1976. 12″ x 8″. Brocade, embroidery thread, rhinestones, fur, satin, and polyester fiberfill. Quilted, embroidered, and appliquéd. This startling and whimsical piece was fashioned from friends' remnants, odds and ends that appealed to the artist's fascination for the use of memorabilia in her work. Photograph: Clark Quin. (Jack and Mary Weiner)

128 (left). *Berkshires by Moonlight*, Agusta Agustsson, 1977. 25″ x 25″. Brocade, satin, embroidery thread, cotton, corduroy, and polyester fiberfill. Pieced, sculpted, and quilted. Part of a series of landscapes, this piece depends on dark colors and soft fabrics to evoke a sense of suspended time and motion. The ingenious, stuffed headlights give a special charm to the piece. Photograph: Clark Quin. (Artist's collection)

130 (right). *Colorado*, Agusta Agustsson, 1975. 25″ x 25″. Brocade, satin, taffeta, cotton, fake fur, corduroy, and polyester fiberfill. Cut, pieced, sculpted, and quilted. Miniature pine trees, snow-capped peaks, and a sunlit meadow create an irresistible vista. Photograph; Clark Quin. (Artist's collection)

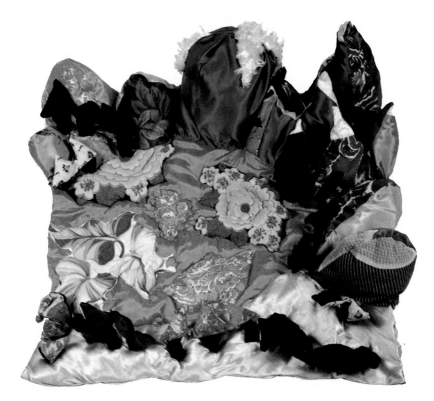

129 (below). *Puerto Rico*, Agusta Agustsson, 1976. 25″ x 25″. Satin, silk thread, cotton, polyester fiberfill, and hand-painted silk birds. Stitched and assembled. Birds, flowers, and waves combine to make a tiny tropical paradise. Photograph: Clark Quin. (Artist's collection)

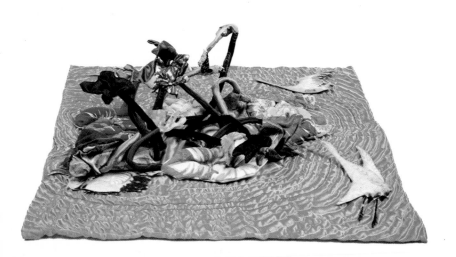

131 (left). *Sometimes Love Comes in Disguise,*
Madeleine Thomson, 1976. 16″ x 13″ x 7″. Velvet, satin,
Mexican cotton, ribbons, and bells. Pieced, appliquéd,
and stuffed. A mirthful celebration of love through the use
of the heart motive, this piece utilizes various textured
fabrics in warm colors to convey provocative messages.
Photograph: Clark Quin. (Paul Raphael Lapesqueur)

132 (left). *Hooray for Art,* Madeleine Thomson, 1977.
24″ x 16″ x 5″. Brocade, velvet, Mexican cotton, embroidered
ribbon, blanket wool, and felt. Stitched, pieced, quilted,
and stuffed. The artist celebrates the visual joy of art
through the use of favorite personal and universal symbols:
bananas, stars, hearts, and flowers. Photograph: Clark Quin.
(Abram Whyte)

133 (above). *Banana Queen's Gorilla Disguise,* Madeleine
Thomson, 1974. 16″ x 15″ x 5″. Linen, cotton, and brocade.
Pieced, stuffed, appliquéd; thread relief. The bold,
primitive quality of this amicable gorilla mask is softened
by the use of delicate brocades, velvets, and silk.
Photograph: Clark Quin. (Artist's collection)

71

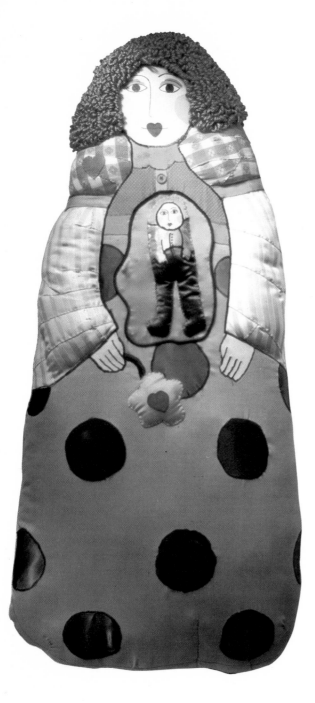

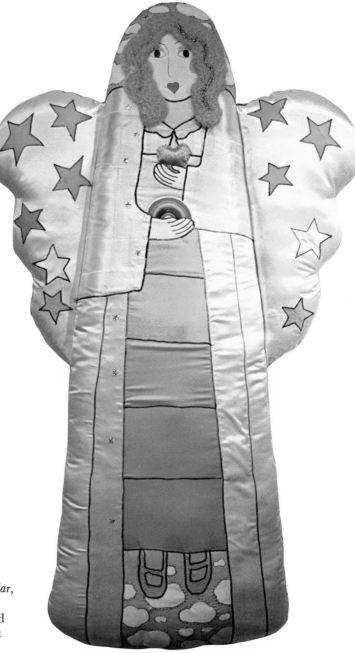

134 (left). *Another Mother*, Karen Bradford, 1974. 50″ x 32″ x 8″. Cotton, satin, yarn, acrylic paint, and polyester fiberfill. Appliquéd, stitched, and painted. One of a collection of life-size dolls, this makes a clever statement of its own. Photograph: Karen Bradford. (Artist's collection)

135 (right). *In Heaven an Angel Is No One in Particular*, Karen Bradford, 1974. 72″ x 34″ x 8″. Mohair, satin, cotton, paint, and glitter. Stitched, appliquéd, hooked, and painted. This piece was inspired by a Zen riddle about futility and specialness that appealed to the artist. Photograph: Karen Bradford. (Artist's collection)

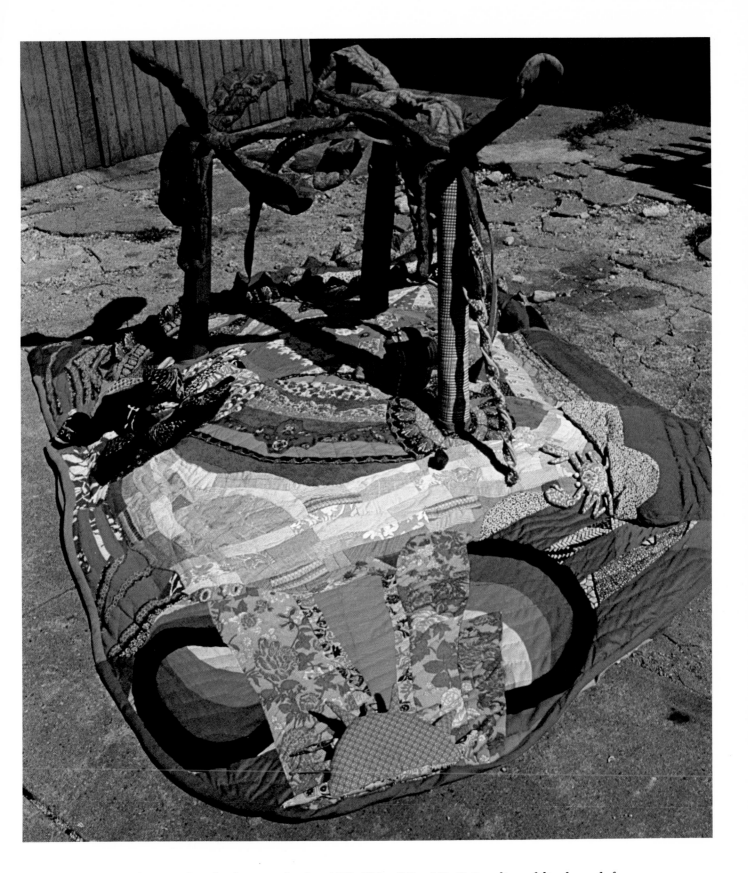

136 (above). *The Island,* Jan Dubinsky, 1976. 72″ x 54″ x 36″. Cotton, linen, felt, plywood, foam, styrofoam, and wire. Pieced, appliquéd, stuffed, molded, and quilted. Conceived as an environment to be physically experienced by a child, and assembled with safety in mind, this soft sculpture appeals as well to adult imaginations, with its brilliant colors, textured fabrics, and exotic forms. Photograph: Mimi Dolbier. (Cindy Schwartz)

137 (left). *Each Cloud Has a Silver Lining*, Alice Whitman Leeds, 1972. 8″ x 8″ x 13″. Satin, velvet, and silver lamé. Stitched, embroidered, trapunto quilted, and stuffed. This satin box contains several separate clouds that can be removed, each bearing a hand-embroidered message. Photograph: Doug Long. (Mr. and Mrs. Louis Meyers)

138 (below). *Harvest Jewel*, Shirley Britton, 1976. 16″ x 18″. Velveteen, faille, silk, felt, and crystal beads. Pieced, crocheted, and stitched; wired construction. A literal rendering of a familiar object, this piece celebrates the essence of the autumn harvest. Photograph: Shirley Britton. (Mr. and Mrs. David A. Bridger)

139 (opposite, left). *Corn Quilt*, Bonnie P. Boudra, 1976. Unrolled: 72″ x 55″; assembled: 70″ x 14″ x 13″. Cotton, wool, yarn, and batting. Stitched and biscuit-quilted. Delightful and certainly original, this piece is just too corny for words! Photograph: Paul W. Boudra, Jr. (Artist's collection)

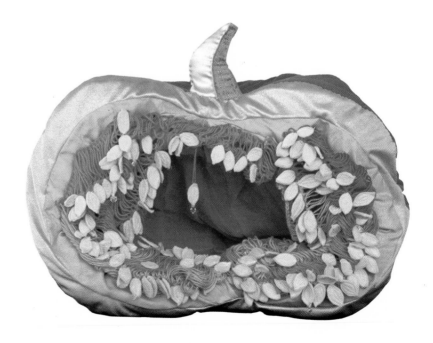

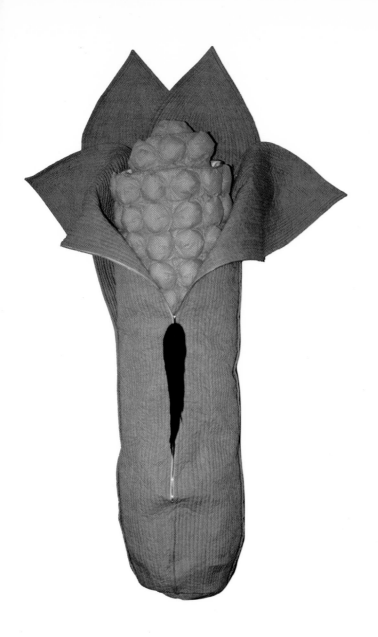

140 (above, right). *Ruth's Tea House,* Joyce Marquess, 1976. 12″ x 12″ x 12″. Satin, velveteen, gold lamé. Appliquéd and quilted. This tea cozy was a loving, housewarming gift for the artist's friend. Photograph: Joyce Marquess. (Ruth Kao)

141 (right). *Cacti,* Felice Regan, 1977. 40″ x 54″. Cotton, and stuffing. Stitched and stuffed. This piece is a departure from typical quilt assemblage in that the repeated form and image familiar in quilting exist in space instead of against a fabric background. Photograph: Carol Beckwith. (Artist's collection)

ARTISTS' BIOGRAPHIES

LINDA ABRAMS has been working with fabric since 1973. Birds and flowers, infused with a sense of mystery and beauty, are her main themes. She is also a painter and gilder and works in stained glass and assemblage; she is currently working with reverse glass painting.

AGUSTA AGUSTSSON is a painter, printmaker, and sculptor. She is part of The Graphic Workshop in Boston, and she sews with a fabric artists' group, Silver Threads and Golden Needles, once a week.

CAROL BECKWITH is a painter, photographer, and fabric artist from Boston. She has traveled extensively through the Orient, Southeast Asia, Oceania, and Africa. The sources of inspiration for her work have come directly from her experiences in exotic cultures. She has exhibited in galleries and museums in the United States, Kenya, and Japan. At present she is working on a book of color photographs of the Masai people of Kenya and Tanzania.

HELEN BITAR received her Bachelor of Science in printmaking at the University of Washington, where she also worked independently on fabric and fiber projects. She has received numerous awards and grants for her innovative work in cloth, which has been exhibited widely and reproduced in many publications. She lives in Portland, Oregon.

LAURA BLACKLOW received her Master of Fine Arts in photography at Visual Studies Workshop, Rochester, New York. She likes to apply traditional techniques in nonconventional formats and utilizes various graphic and photographic processes in her cloth art. She has given workshops at Project, Inc., Cambridge, Massachusetts, and she teaches photography at Emerson College, Boston.

BONNIE P. BOUDRA is a quiltmaker, working on both two- and three-dimensional quilts. Her work has appeared in many national exhibits, including The 1977 Museum of Contemporary Crafts of the American Crafts Council Exhibit: Young Americans: Wood/Fiber/Leather/Plastic in New York.

KAREN BRADFORD who "has been a waitress long enough," has now shown her fabric work extensively in Boston, where she sewed with Silver Threads and Golden Needles, and in New York, where she lives. She makes paintings, rugs, dolls, and quilts.

EVELYN BRENNER, a potter for many years, became interested in fabric and began making collage tapestries, sometimes with clay as well as cloth. She has exhibited widely, has received several awards for her work, and is currently represented by two New York galleries.

NANCY BRITTON is a textile artist and quiltmaker who lives in Salem, Massachusetts. She works extensively in weaving, dyeing, and fabric printing. Her work has been featured in textile publications and has been exhibited throughout New England. She teaches her skills to groups of all ages.

SHIRLEY BRITTON explores methods of updating needle art skills. She is on the faculty of the Brockton Art Center, Fuller Memorial, Brockton, Massachusetts, and also teaches fabric techniques for the Bay Colony Society of Embroiderers, Chestnut Hill, Massachusetts. Her home is in Plymouth.

KATHLEEN CARACCIO, born in 1947, is a master printer working at her own studio in New York. A quilt she designed was featured in the Pratt Graphics Center's Printed Quilts, Quilted Prints exhibit in 1976. Her work was exhibited at The Brooklyn Museum's Print Biennial, 1975, and she has had a one-person Works on Paper Exhibit at the Institute of Puerto Rican Culture.

JEAN CARLSON has been working with fabric since she attended the Rhode Island School of Design where she received her Bachelor of Fine Arts. During that time, she placed in the New York Society of Illustrators' Student Scholarship Competition in 1973, 1974, and 1975. Her work has been exhibited at The New-York Historical Society. She currently teaches art at South Burlington High School, Vermont.

DIANE CASTELLAN is currently a fifth year candidate for the Bachelor of Fine Arts degree in textile design at the Cleveland Institute of Art. In her fabric pieces, she tries to incorporate traditional and contemporary ideas and forms. Her work was included in The 1977 Museum of Contemporary Crafts of the American Crafts Council Exhibit: Young Americans: Wood/Fiber/Leather/Plastic. She is also a glassblower.

PATTIE CHASE is a fourth-generation quiltmaker. She has been making contemporary fabric art, pieced and appliquéd fantasy garments in particular, since 1970. She has exhibited her work in California and in New England and will be included in an exhibit of work by contemporary fabric artists at the Main Gallery, Boston City Hall, in December 1978. She lives in Cambridge, Massachusetts, and is currently at work on her second book.

SAS COLBY is a fantasy artist who makes boxes, books, masks, capes, and quilted wall hangings out of fabric. Her work has been published and shown extensively, and she teaches workshops on creativity.

BARBARA COMSTOCK is a textile artist whose work in fabric has evolved through her work at the University of Wisconsin and at the California College of Arts and Crafts, where she now teaches. She has received numerous awards and wide recognition for her work. One of her pieces was included in The 1977 Museum of Contemporary Crafts of the American Crafts Council Exhibit: Young Americans: Wood/Fiber/Leather/Plastic in New York. She lives in Berkeley, California.

SUZANNE DERRER is a self-taught fabric artist who lists natural history and the camouflage techniques of plants and animals as major influences in her work. She has done extensive batik and some welding and metal sculpture.

RADKA DONNELL gave up painting to make quilts full time in 1963. She works to achieve mastery of the design problem within the quilt's rectangular format, for personal expression, and to reach others by talking about quilts. She has exhibited her work extensively throughout the United States and in Europe.

JAN DUBINSKY, a biomedical engineer, has been making fabric art since 1972. Her Island, a sculptured environment for children, was preceded by her interest in and involvement with pieced quilts. She took part in the Fabrications Quilt Exhibit in Cambridge, Massachusetts, in 1972.

LEE FARRINGTON is a self-taught artist with a background in dance. She teaches classes in contemporary and traditional quiltmaking at adult education centers in the Boston area.

LESLIE FULLER, born in California, is a well-known fabric artist who now makes her home in Vermont. She works in film and architectural design, as well as in cloth art.

SUSAN FULMER is a quiltmaker who works on commission and has been represented by Julie: Artisan's Gallery in New York. She is currently exploring various techniques for dyeing fabric. She lives in Cambridge, Massachusetts.

ANN GATI received her Master of Arts from Goddard College in 1977. Currently she is doing commissioned work, mainly "psychic portraits," and teaching in the Niskaguna, New York, public schools. Her work is shown in Boston at Sans Regret Gallery, and at Art Resources Open to Women, Schenectady, New York.

BETSY GROB GIBERSON studied sculpture at the Rhode Island School of Design. She has worked in cloth since 1974. She lives in Warner, New Hampshire.

JUDITH STEELE GOETEMANN has emerged over the past two years as a professional artist, working extensively in the area of batik printing. Her work has been shown at the (1977) International Flags and Kites Show (Seattle); at Focus on Crafts, a National Crafts Council Exhibition at the University of Minnesota, 1977; and at The Gallery, which she owns, in East Gloucester, Massachusetts.

SUSAN GOFSTEIN is a painter living in Providence. She received her Bachelor of Fine Arts from the Rhode Island School of Design and has exhibited her stitchery and paintings at group shows in the Rhode Island area.

GWEN-LIN GOO, born in Honolulu, received a Bachelor of Art Education from the School of The Art Institute of Chicago and her Master of Fine Arts from Cranbrook Academy of Art. She has exhibited extensively throughout the United States and has taught at the Cleveland Institute of Art, the University of Michigan, and the School of The Art Institute of Chicago. Currently she teaches textile design at Boston University. Besides working in fabric, and in combination with it, she works with plastics, wood, polyurethane foam, clay, glass, and leather.

SUSAN HOFFMAN has been working in the medium of quilted tapestries for seven years and is self-taught. Her work is currently represented by the Kornblee Gallery in New York, and she has exhibited at the Carpenter Center for the Visual Arts, Harvard University; The Institute of Contemporary Art (Boston); The Museum of Contemporary Crafts of the American Crafts Council (New York); and the Smith-Anderson Gallery in San Francisco. She is the recipient of a grant from the National Endowment for the Arts and is now working on a book of her work. She lives in New York.

SANDRA HUMBERSON is a candidate for Master of Fine Arts at The Maryland Institute, College of Art. She works with wood, as well as with cloth, and has combined wood and fabric in sculptural pieces. Many of her images are inspired by music, and she is especially interested in grass-roots music, such as Bluegrass and jazz.

ANN HUTCHINSON attended the Rhode Island School of Design where she studied with Norman Laliberte and Richard Merkin. Although she has done a great deal of drawing and painting, her primary interest is fabric art. She has exhibited at New England Society of Arts and Crafts, Newburyport, Massachusetts, and at Territorial Gallery, Sante Fe, New Mexico. She now has her own gallery, Fabric Images, in Santa Fe.

KAREN KATZ is a free-lance illustrator and fabric artist who lives in New York City. For several years she has designed costumes for Doug Henning's television specials, "The World of Magic," and is currently designing tapestries on commission.

JODY KLEIN has exhibited her fabric sculptures, quilts, and fabric-and-paper assemblages throughout the United States. She was included in the Object as Poet exhibition at the Renwick Gallery of the Smithsonian Institution in 1977, and in the International Surface Design Exhibition, Purdue University in 1978. She has received numerous awards and grants for her work, recently lecturing and conducting workshops in England under a grant from National Endowment for the Arts through the American Crafts Council.

REBECCA SCOTT LACKMAN graduated from Montana State University where she was first inspired by women working with fabric. Although accomplished in painting, drawing, and printmaking, she feels most at home working with cloth. As a teacher of Transcendental Meditation, she is dedicated to the development of consciousness and the expression of that growth. She lives in Marlboro, Massachusetts.

ALICE WHITMAN LEEDS is self-taught and intentionally avoids structured study. She has won several awards for her work. She currently lectures on cyanotypes incorporated in soft sculptures, and on "writing and drawing with a sewing machine."

MEREDITH LIGHTBOWN, who studied at the Rhode Island School of Design, is an illustrator who has received the American Institute of Graphic Arts Award of Excellence in Illustration. She has lived and worked in Switzerland and now lives in Cambridge, Massachusetts.

TANA KRIZOVA LIZON, a painter who recently began working with fabric, received her Master of Fine Arts in her native Czechoslovakia. She has studied at the Pennsylvania Academy of Fine Arts and has exhibited in Pennsylvania, Tennessee, Mexico, and Czechoslovakia. Her work has appeared

in several publications and has received awards. She has designed book and magazine covers, catalogues, and posters in the United States and Europe, has produced two animated films for Czechoslovak television, and has created several murals on commission in Pennsylvania and Tennessee. She lives in Silver Spring, Maryland.

KAREN M. LUKAS began using fiber and fabric as a medium to express her interest in colors while studying for a Bachelor of Fine Arts degree at the Massachusetts College of Art. Working in what she refers to as a "painterly fashion," she continues to explore the infinite facets of color interaction. She lives in Cambridge, Massachusetts.

BARBARA MARCKS is a quiltmaker whose work has been exhibited in the Boston area for some time. She was awarded first prize for her quilt in the Design Research Quilt Competition, 1975, and her work was shown in "Bed and Board," a contemporary quilt exhibit at the DeCordova Museum (Lincoln) in 1974. She lives and works in Lincoln, Massachusetts, where she makes rya rugs, as well as quilts.

JOYCE MARQUESS teaches weaving at the University of Wisconsin, Madison. She works mainly with multi-harness weave structures, but she also does considerable work with quilting. Her design themes derive from ideas of cycles, change, and metamorphosis.

PAULA JO MEYERS, who lives in California, is currently experimenting with natural dyeing of cotton. She is self-taught and makes patchwork quilts, quilted pillows, and quilted wall hangings.

CINDY MIRACLE incorporates her background in painting and photography into multidimensional fabric collage. She received her Bachelor of Arts from California State University, Fullerton, in 1971 and her Master of Fine Arts from Claremont Graduate School in 1977. Currently she is teaching at San Jose State University. Her work has been exhibited throughout California and is included in the International Surface Design Exhibition, Purdue University, 1978.

MARY ELLEN MOSCARDELLI is a textile artist who has also worked throughout New England in the field of Environmental Studies. She received a Master of Fine Arts from Temple University's Tyler School of Art in 1975 and now operates a design studio in Boston.

JAN MOSEMAN received a Master of Science in textile design and a Master of Fine Arts in graphics at the University of Wisconsin where she made prints on fabric and sculpture from prints. She currently designs hand-dyed silks in her loft in Boston, and her designs have appeared in *Vogue*, *Mademoiselle*, and *Glamour*. She makes cloth sculptures, teaches at the DeCordova Museum (Lincoln), and gives workshops in the Boston area.

SHARON MYERS began her involvement with art with sculpture, and her love of color and design brought her to the use of fabric and fiber. Her woven wall hangings and quilts have a tactile, sculptural quality. She teaches in Boston, and has studied and exhibited throughout New England.

RISË NAGIN began working in fabric while studying painting at Carnegie-Mellon University, where she received a Bachelor of Fine Arts in 1972. Her work is shown at the Helen Drutt Gallery, Philadelphia, and at Julie: Artisans' Gallery, New York.

CYNTHIA NIXON received her Master of Education in Art Education from Pennsylvania State University. A trip to Central America provided the impetus for her present work, which involves rich color and natural imagery. She is largely self-taught in the techniques that she combines: pen and ink drawing on muslin, satin appliqué, and quilting. Her figurative wall hangings and soft sculptures have been exhibited throughout the eastern United States.

MARILYN R. PAPPAS works in fabric collage. She received a National Endowment for the Arts Craftsman Fellowship Grant in 1973. She has given numerous workshops and currently teaches at the Massachusetts College of Art, Boston.

SHEILA PEREZ, who received her Bachelor of Fine Arts from Hartford Art School, University of Hartford, incorporates her painting background into fabric works. Her work is exhibited in many galleries on the East Coast and is in many private collections. Two of her pieces were included in The 1977 Museum of Contemporary Crafts of the American Crafts Council Exhibit: Young Americans; Wood/Fiber/Leather/Plastic in New York. She teaches drawing in Connecticut, where she also gives workshops in contemporary quilting.

JOAN A. PETERS works in fabric collage, watercolor, and drawing. Largely self-taught, she has taken and given workshops on fabric techniques. In Brattleboro, where she lives, "the Vermont landscape and the continual play of form and color within its natural elements provide endless inspiration."

FELICE REGAN is a graphic designer and silk-screen printer with a Bachelor of Fine Arts from the Massachusetts College of Art. One of the founders of The Graphic Workshop, Boston, her prints have been exhibited throughout the world. She has taught at St. Andrews School in Tennessee and the Chamberlain School of Retailing at Boston. She is also associated with Silver Threads and Golden Needles, a Boston fabric artists' group.

WENDY ROSS received a degree in communications design from the Rhode Island School of Design. She has worked in fabric for the past several years, and also works in stained glass, graphics, and illustration. She now lives on the West Coast and is at work on both a master's degree and her first children's book.

MARION K. SIMS is a printmaker whose etchings, silk screens, silk-screened fabrics, and handmade paper prints are experimental and "preferably nonprofit-making" in orientation. Her work has been shown in the United States, Mexico, South America, Europe, and Korea. She is currently printing a book about the print workshop she attended at the Camnitzer-Porter Studio near Lucca, Italy, in the summer of 1977.

LENI SINGERMAN, a textile designer now living and working in New York, received her Bachelor of Fine Arts from the Rhode Island School of Design. She works primarily in batik and screen printing, and has exhibited in the Rhode Island/Connecticut area.

JOY STOCKSDALE, who lives in California, works in enameling and ceramics, as well as in fabric. She has given workshops on inventive stitchery and currently teaches quilting and embroidery in Berkeley and San Francisco.

MADELEINE THOMSON attended Silvermine College of Art and the San Francisco Art Institute College. As a trained graphic artist and self-taught weaver, she uses cloth and thread as a painter, designer, and visual poet. She has taught at the Haystack Mountain School of Crafts, Deer Isle, Maine, and at various New England colleges, and has conducted workshops at The Great Golden Banana Factory in Laconia, New Hampshire. Her work is in private collections throughout the United States, Canada, and Mexico.

MOLLY UPTON (1953-1977) was self-taught in her work with fabric, although she studied art at Macalester College and the University of New Hampshire. Her work was represented by the Kornblee Gallery in New York and has been exhibited at the DeCordova Museum in Lincoln, Massachusetts, the Los Angeles County Museum of Art, and in galleries and museums in San Francisco, Boston, and Tokyo. She had received a grant from National Endowment for the Arts in 1975.

CLARA WAINWRIGHT is a fabric artist who calls her work "pictures made with cloth." Well known for the startling and unique effects she achieves in her cloth pieces, she also created and developed two of Boston's most spectacular public celebrations: First Night (a New Year's Eve celebration) and The Great Boston Kite Festival.

WENDA F. VON WEISE makes functional quilts and fabric collage and also works with photography: graphic photo processes, photo intaglio, photo emulsion on paper with drawing and collage. She studied at Visual Studies Workshop, Rochester, New York, and has taught workshops in the Cleveland area in photo screen printing and photo techniques for fabric. Currently she is a degree candidate at Cranbrook Academy of Art, Michigan. She lives in Gates Mills, Ohio.

NANCY WRIGHT is a self-taught quiltmaker. In addition to her portrait quilts, she has created a series of wildflower and landscape quilts incorporating hand- and machine-quilting, piecing, appliquéing, hand dyeing, silk-screening, painting, and tie-dyeing. She was instrumental in forming The Red Tulip Guild, a quilters' cooperative in Waitsfield, Vermont. She now lives in Boston.

INDEX